IMAGES
of America

ALTOONA

D1572082

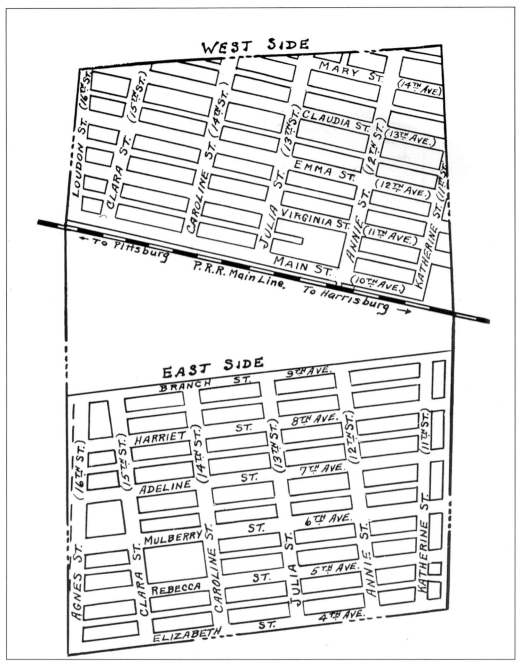

An interesting story surrounds the naming of the streets and avenues of early Altoona. Laid out in 1849, the area was populated with railroad personnel, many of whom were temporarily living in boardinghouses and had not yet built homes here. These men missed their mothers, wives, and sweethearts—hence, they named the new roads after these women. Thus, the Logan House stood on the corner of Virginia Street and Annie Avenue, and Blessed Sacrament Cathedral was located on Julia Avenue between Emma and Mary Streets.

IMAGES
of America

ALTOONA

Sr. Anne Frances Pulling

ARCADIA

Copyright © 2001 by Sr. Anne Frances Pulling.
ISBN 0-7385-0516-1

First printed in 2001.

Published by Arcadia Publishing,
an imprint of Tempus Publishing, Inc.
2A Cumberland Street
Charleston, SC 29401

Printed in Great Britain.

Library of Congress Catalog Card Number: 2001088388

For all general information contact Arcadia Publishing at:
Telephone 843-853-2070
Fax 843-853-0044
E-Mail sales@arcadiapublishing.com

For customer service and orders:
Toll-Free 1-888-313-2665

Visit us on the internet at http://www.arcadiapublishing.com

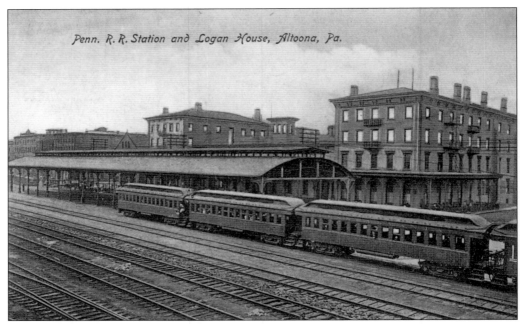

Penn. R. R. Station and Logan House, Altoona, Pa.

The Logan House was a prominent spot for visitors to Altoona. Built by the Pennsylvania Railroad, it adjoined the original railroad station, shown in the foreground. In 1855, it was dubbed a "Mansion in the Wilderness," since the entire area was a wilderness when J. Edgar Thompson arrived on the scene and laid a rail route over the mountain. Note the walkway beneath the canopy, between the station and the building.

CONTENTS

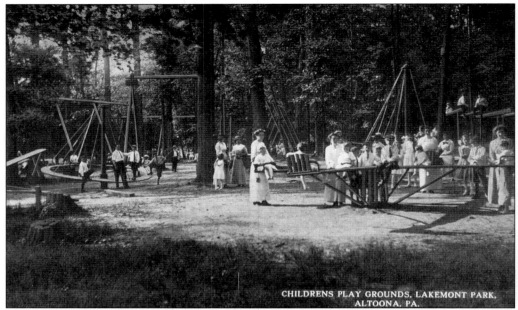

CHILDRENS PLAY GROUNDS, LAKEMONT PARK, ALTOONA, PA.

The children's playground was one of the first attractions at Lakemont Park. It was designed for small children before the amusements were installed. The idea for a park in the unusually picturesque Lakemont area—an area in which ore was once mined—was initiated by a group of volunteers headed by the newly formed Logan Valley Railway. The group held a picnic in Lakemont to discuss the feasibility of developing a park there. That was the beginning of the grand park that Altoona enjoys today.

Acknowledgments

This publication is based on research, records, periodicals, documents, newspapers, and interviews with townspeople knowledgeable about local history, many of whom supplied information and offered constructive suggestions. A special thank-you goes to Tim Vanscoyoc of the Blair County Historical Society for sharing many photographs and a wealth of knowledge.

Sincere thanks also go to members of the Railroaders Memorial Museum and to James R. Stine for his expertise on the railroads. In addition, gratitude is extended to the Altoona Chamber of Commerce, the Blair County Geological Society, Lisa McManus of TV Channel 10, Bon Secours Hospital, the Altoona Public Library, Dale Woomer of the Jaffa Mosque, Dawn Hand of Penn Alto Hotel, photographer Tom Pollard, and Rev. Msgr. Timothy Stein of the Catholic Register.

Also, thanks go to Rev. Daniel Sinisi, TOR, and Peggy Goodman for their valuable assistance. Prayerful gratitude goes to all who helped by supplying photographs, assisting with captions, and proofreading. Finally, a word of thanks to the Sisters of Mercy of the Dallas Regional Community for support and encouragement of this project.

INTRODUCTION

Altoona, the Mountain City, lies nestled in the foothills of the Alleghenies. It evolved with the Pennsylvania Railroad and has long been known as the Railroad Capital of the World. In 1849, when the slender rails of steel reached David Robeson's 223-acre farm, now Altoona, the site was chosen for its topography. The railroad had completed a single track known as the Gateway to the West.

The railroad had rumbled across the state from New York and Philadelphia. The Allegheny Mountains presented a unique challenge to westward expansion. It took the engineering genius of man to conquer the mountain range. Through the efforts of J. Edgar Thompson, the railroad climbed the steep 1,594-foot incline on an all-rail route that took it around the now famous Horseshoe Curve, through the distinguished Gallitzin Tunnels, and over the crest of the Alleghenies. The 2,375-foot curve gracefully circles Altoona Reservoir on the eastern slope of the mountains. Completed on February 15, 1854, the curve cut travel time between Philadelphia and Pittsburgh from four days to eight hours. To the credit of its founders and the 400 Irish immigrants from County Cork, Ireland, who built it, after 15 decades Horseshoe Curve continues to meet the daily needs of the railroad industry.

Cities usually grow to maturity and then sprout suburbs. With Altoona it was just the opposite. The area's early history lies outside of town. The suburbs are older than the city and form a larger community. Altoona is the newcomer. Unlike budding communities chosen for convenience, Altoona emerged out of operational necessity. It was the choice of keen and resourceful engineers. The city centered on the railroad, with its complex that occupied more than 200 acres, and the population multiplied with the various railroad shops that provided employment to early settlers.

As transportation technology increased rapidly, the necessity arose for skilled craftsmen and engineers to staff the shops. The railroad turned to Germany and England for experienced men, who quickly became supervisors and trained a growing staff of local employees. A formal apprenticeship program was established. Altoona shops housed not only railroad maintenance but also production centers, where locomotives were designed and constructed. Many innovations in the railroad industry were conceived in Altoona's local shops.

The luxuriously designed Logan House was constructed in 1855 as an office, a boardinghouse, and a hospitality center. This "Mansion in the Wilderness" made history on September 24, 1862, when Gov. Andrew Curtin of Pennsylvania convened the Conference of Loyal War Governors here. The conference became a vital link in a chain of railroad networks that bound

the Northern states together during the Civil War. It culminated in a pledge of confidence and loyalty to Pres. Abraham Lincoln—a declaration that was presented to the president in person.

Altoona was known for its iron furnaces, which were huge operations. Charcoal was used in the manufacture of iron until 1850. To provide an adequate amount of charcoal, an ironmaster had to own immense amounts of ore and timber. Elias Baker owned the Allegheny Furnace, which still stands in Altoona.

In 1882, the horse-drawn streetcar began operation and, in 1891, the electric trolley became a reality. The trolley provided transportation to outlying hamlets. Its earliest distant run was along Logan Boulevard, past Lakemont Park, and on to Hollidaysburg, the county seat. Altoona, incorporated in 1854, is the only city in Blair County. Lakemont, a place of natural beauty, became a recreational center with many attractions. After its picnic meeting in 1893, the Logan Valley Electric Railway Company obtained land and deeded it to Lakemont Park for a man-made lake. Plans for the construction of an amusement park followed.

The campus of Penn State University was once Ivyside Amusement Park. In 1920, Raymond Smith came up with the idea for a park. It was developed on 40 acres of donated land along Juniata Gap. An Olympic-sized swimming pool and bathhouse were constructed and rides were added. The park flourished for two decades before the Depression and World War II took their toll. The park was phased into history, and Penn State purchased the land for a campus.

Pennsylvania State University, founded in State College in 1855, established an undergraduate center in Altoona in 1939. Classes were originally held in the former Webster School. In 1948, when classes began at Ivyside, the bathhouse was the main building, the roller rink served as the student union, the concession stand housed the steam plant, and the world's largest concrete swimming pool became a parking lot. Today, the Altoona campus includes 20 buildings on 115 rustic acres. It offers degrees in the sciences, arts, nursing, and electrical engineering technology, as well as continuing education seminars on various subjects related to business, industry, and entertainment.

Altoona housed more manufacturing agencies than any other area in central Pennsylvania. These agencies set up businesses that supplemented the railroad. Enterprising citizens developed possibilities that rounded out economic life. Merchandising became so prominent that Altoona became the buying center for a quarter of a million people, the chief shopping center of Blair County. Throughout the city, department stores were numerous and there was never a dearth of employment in Altoona.

New trends continued to emerge. As the railroad declined, other industries sprang up. City life shifted from the downtown to outlying areas; yet Altoona remained a shopper's haven. Culture, religion, and social life were a vital part of Railroad City. Today, beauty, friendship, civic virtue, character, and success are still found abundantly in Altoona. The intent of the chapters that follow is to recapture and preserve an era that conquered the frontier in the foothills of the Allegheny Mountains.

One

STEEL RAILS
TO THE WEST

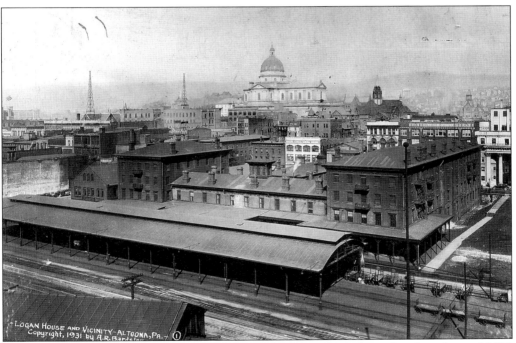

LOGAN HOUSE AND VICINITY-ALTOONA, PA.
Copyright, 1931 by A.R. Bards[...]

The city of Altoona centered on the railroad. This view from the railroad yards is of 1930 vintage. The railroad station and the Logan House are in the foreground, and Blessed Sacrament Roman Catholic Cathedral rises in the distance. Rolling mountains surround the city, giving it a distinctive backdrop. During the spring and summer, they form a widespread vista. In the autumn they become a blaze of glory, and in the winter they continue to lend their beauty to the stark landscape.

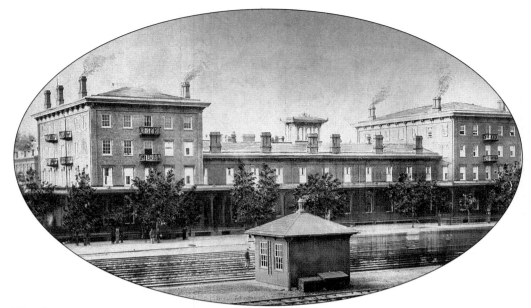

The Logan House was constructed in 1855 as an office and boardinghouse for railroad personnel. Named for Cayuga Chief John Logan, this luxuriously designed "Mansion in the Wilderness" was located on the corner of Eleventh Avenue and Twelfth Street. A historic event took place here on September 24, 1862, when Gov. Andrew G. Curtin called a Conference of Loyal War Governors. The conference resulted in a binding of the Northern states and a pledge of confidence and loyalty to Pres. Abraham Lincoln.

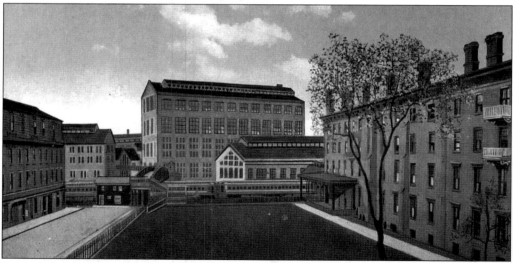

Logan House Park was located adjacent to the railroad yards. The 106-room house hosted three presidents: Ulysses S. Grant, Rutherford B. Hayes, and William Howard Taft. First lady Mary Lincoln and her children were housed here, as were industrialist tycoon Andrew Carnegie, military generals, and the statesmen who attended the Conference of Loyal War Governors. Humorist Robert J. Bardette offered this assessment of the place: "The Logan House is about the size of Rhode Island." In the left background of this c. 1920 photograph is a footbridge for getting across the tracks to the railroad station.

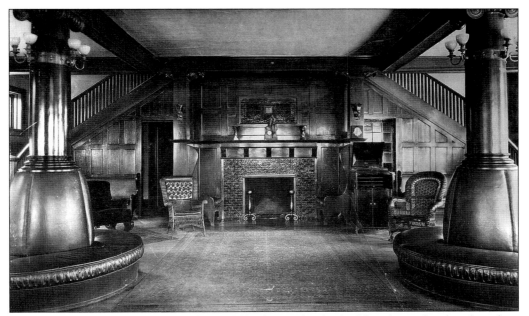

The interior of Logan House was beautifully designed. The building housed railroad workers and dignitaries alike. It was named after John Logan, a Cayuga chief who was prominent in the area a century earlier. Logan always maintained friendly relations with white people and was very helpful during the Revolution. The Native American word *allatona* means "good land at the foot of the hills." The good land that became Altoona was originally carved from the farm of David Robeson.

The foundry of the Pennsylvania Railroad was located at Ninth Avenue, west of Ninth Street. The first railroad shop was built in the foothills of the eastern slope of the Alleghenies on David Robeson's 223-acre farm, which was purchased for this purpose in 1849. The shop, a foundry where metal casting was done, was established to repair locomotives going over the mountain. It gradually expanded until it occupied the area all the way to Sixteenth Street.

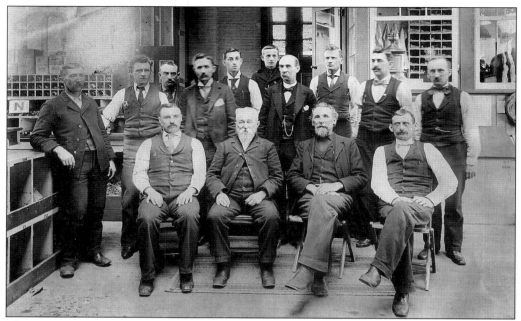

These men are among those who worked at the Fourth Street storeroom of the vast Altoona car works operation. The car works was initially established to repair railroad cars destined to climb the rugged mountain terrain. It expanded rapidly from a small cluster of buildings to a plant encompassing 15 acres. The shop yards alone covered 217 acres, and the plant had more than 100 buildings housing thousands of tools, cranes, and various facilities.

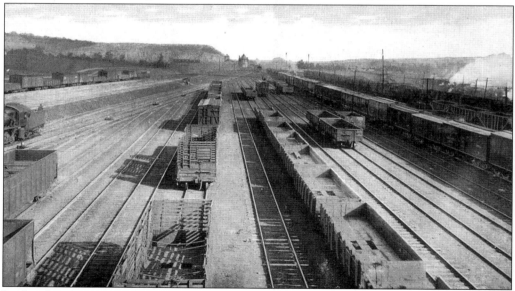

In the classification yards, established in 1902, railroad cars are separated according to weight and destination. The Altoona railroad yards, at the base of the Alleghenies, were the largest in the world. They formed a huge maintenance, repair, and manufacturing center. More than 16,000 freight cars were built in Altoona between 1920 and 1940, and locomotive test plants were established.

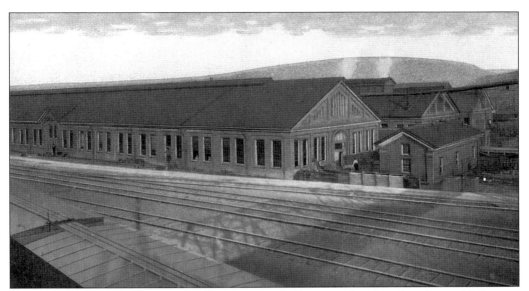

The Fourth Street shops were an early addition to the largest railroad yard in the world. Among the many buildings were the air brake shop, passenger car shop, cab trimming shop, upholstering shop, freight car shop, paint shop, blacksmith shop, tin shop, buffing shop, carving shop, handle shop, and car paint shop. The railroad complex also included a fire engine house, a general foreman's office, planing mills, a cabinet and machine shop, an icehouse, a huge turntable, and several roundhouses.

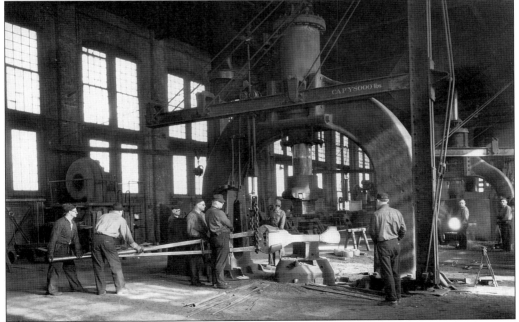

Manufactured and heat-treated locomotive forging was done in this blacksmith shop on Twelfth Street, using the biggest steam hammer in the world. The shop forged main rods for locomotives and, later, produced larger and heavier locomotive sections. The steam for the hammer was supplied by a power plant in the yards near Thirteenth Street.

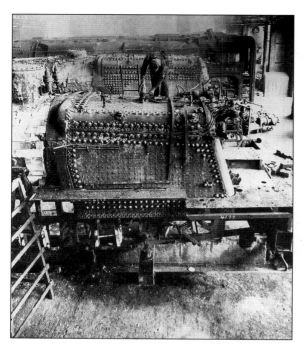

The welding shop was located near the blacksmith shop. Scaffolding was erected so that the workers could reach the top and sides of the locomotives with their welding equipment. Many parts of the locomotives had to be welded, and even more welding became necessary when the railroad began using all metal or steel railroad cars. Welding was also used to restore the cars to service, and it became indispensable during World War II.

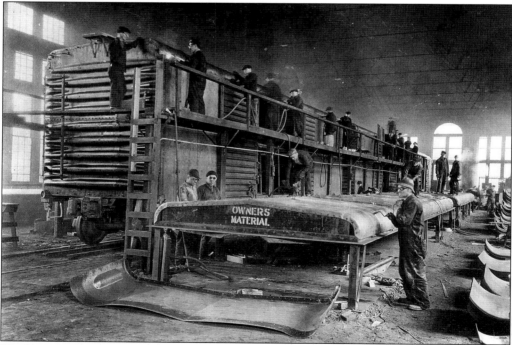

Workers assemble a boxcar at the railroad yards. In Altoona, railroad personnel not only made essential improvements on the boxcar but also developed the first steel car. The first all-steel passenger car rolled out of Altoona on June 11, 1906, and the steel car industry was born. The many coke furnaces in the Altoona area supplied nearby Johnstown with coke and Johnstown, in turn, made its steel available to Altoona for railroad cars.

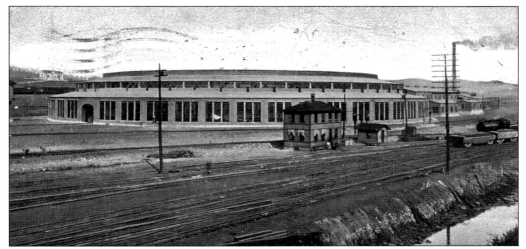

Altoona had the largest railroad yard in the world. In 1904, a 52-stall roundhouse was added to the complex for routine servicing of main line locomotives. Three other roundhouses were constructed to service the railroad cars. Many historical railroad buildings have vanished, but the Alto Tower, the small building in the foreground, has survived. This was a communications block station, a dispatch center that directed railroad traffic.

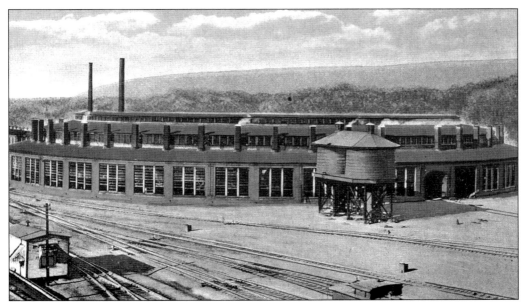

Altoona's engine-handling facilities were greatly increased when the largest roundhouse in the world was constructed near the Juniata Shops in 1916. The roundhouse handled freight passenger cars on all divisions. A total of 16,500 people, from Altoona and its suburbs, were employed at the shops. Note the smokestacks in the background.

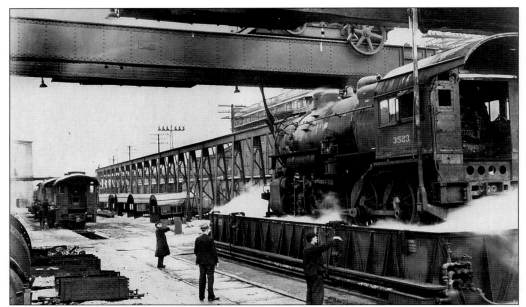

The world's largest lye vat was located at the Twelfth Street ejecting shops in Altoona. The vat was used as a bathtub for locomotives in need of cleaning after years of travel. The locomotives were lifted into the bath of lye by a 150-ton crane. They were put through this cleansing process periodically before being returned to service. A power plant supplied the electricity for the operation.

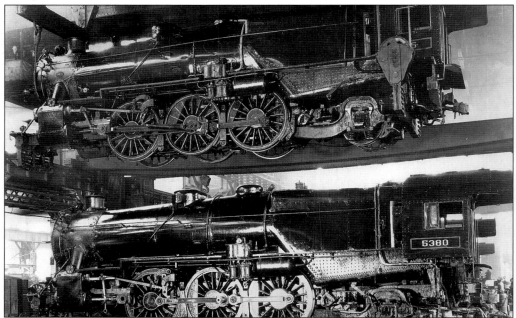

This locomotive has just been overhauled. At this site, 90-ton locomotives were suspended above ground for tests and repairs. They were placed on a test table and, while remaining stationary, were run at speeds of up to 100 miles per hour. A variety of devices measured and registered every phase of the engine operation.

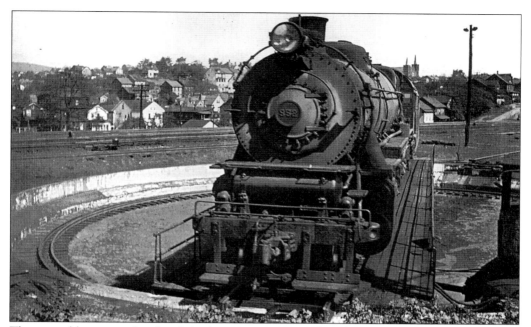

The turntable was used to head the locomotives in another direction. It pointed them either back in the direction from which they came or into the repair shops. This one is being rotated to head west, back up the mountain. In those days, c. 1947, locomotives were turned around, filled with water and coal, and held on standby in case any of the 26 passenger trains needed additional power to climb the mountainous terrain.

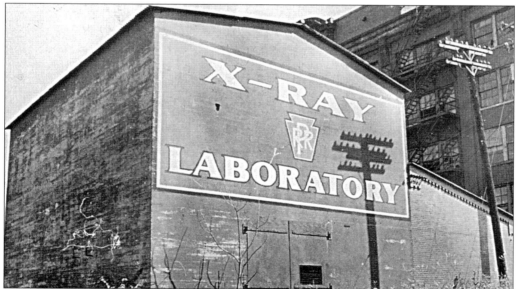

The X-ray laboratory at the Altoona works was designed to determine strength and locate defects in the locomotive. There were many testing centers throughout the complex. The hump and tunnel were testing devices located outside the shops, the last tests before the locomotive was released into service. Testing was vital before locomotives or cars left the Altoona shops. In later years, the dining cars and sleepers were also subjected to rigorous testing.

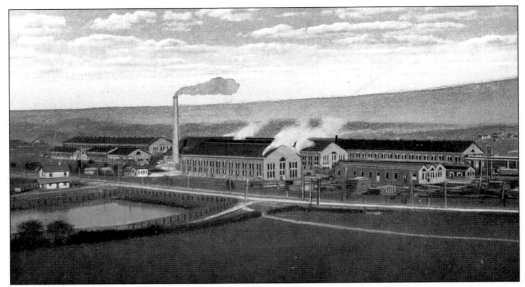

The Juniata railroad shops were built in 1889–1890 to construct new locomotives. As repairs were a necessity, the Juniata shops soon got into that business as well. Following World War I, huge repair shops were constructed in Juniata, where heavy construction and maintenance were also carried out on steam engines and locomotives. Employing more than 5,000 people, the Juniata plant became the largest shop in the unit.

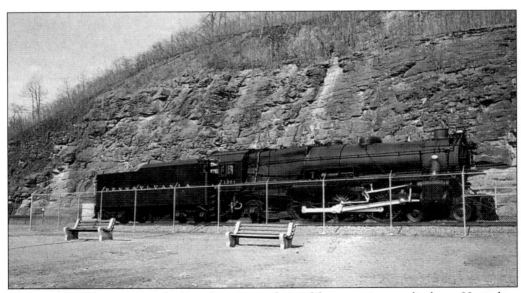

Memorial K-4S locomotive, the Broadway Limited, stood for some time on display at Horseshoe Curve. The locomotive was presented to the city of Altoona by the Pennsylvania Railroad in memory of the Old Iron Horse. It was retired in May 1955, after having traveled nearly 2.5 million miles in the service of the Pennsylvania Railroad.

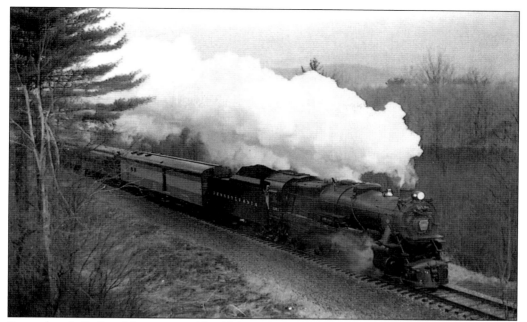

Pennsylvania Railroad Locomotive No. 1361, a class K-4, was taken to the Altoona car shops in the 1980s for renovation. The locomotive had been built in Juniata in 1918 and was in operation until 1956. In the interim, it was out of service. In September 1987, the restored engine pulled railroad cars for the first time in many years. It made a trip to Bellfonte for the enjoyment of many railroad fans. This was its inaugural run after years of display at Horseshoe Curve.

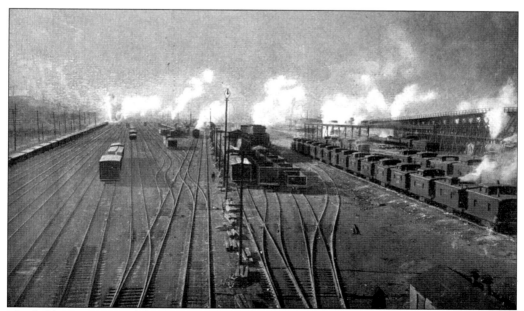

The ladder, a section of the classification yard, serves as a waiting area where locomotives and railroad cars are either held for repair or released for travel. Lined up on the side tracks at the right are cabooses awaiting their destination.

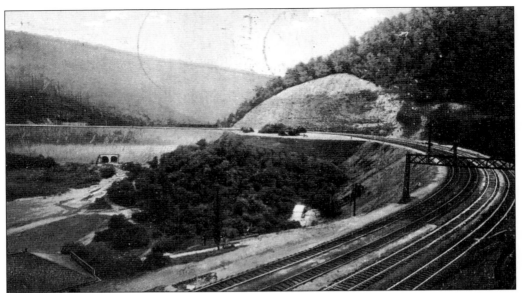

In 1852, J. Edgar Thompson designed Horseshoe Curve, a spectacular route to channel trains around the chasm high on the eastern slope above Altoona. The railroad track ascends the mountain toward the chasm, which divides into two steep ravines. There, it gently curves along the ridge of a valley into a semicircle, or horseshoe. Then it continues to climb toward the Gallitzin Tunnels, where it crests the Allegheny Mountains.

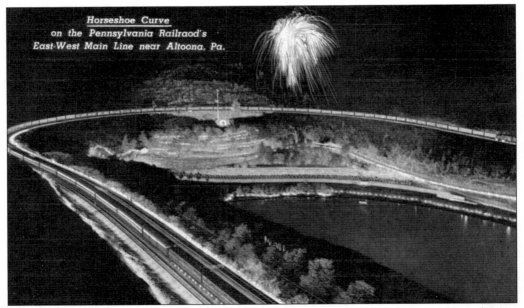

In 1952, the Pennsylvania Railroad and Sylvania Electric Company collaborated to celebrate the 100th birthday of the famous engineering feat known as Horseshoe Curve. The two companies illuminated the 2-million-square-foot area surrounding the famous curve with 6,000 "birthday candles"—actually photographic flashbulbs, equivalent in output to 15 million six-watt lamps. Night photography was at its best for this centenary.

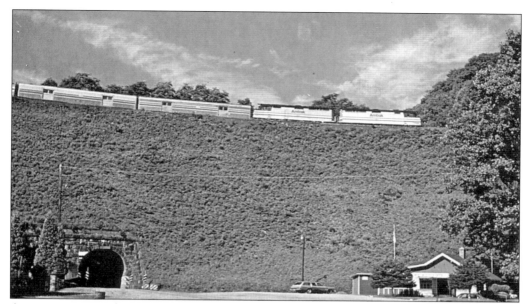

A visitor center and rest area of early vintage nestle at the base of a mountainous embankment. High on the tracks, eastbound Amtrak No. 40, the Broadway Limited, rounds the bend of Horseshoe Curve in 1990. The short tunnel in the lower left leads into Gallitzin. It is to the credit of its designers and builders that 150 years after it was constructed, Horseshoe Curve operates just as efficiently as it did when first built.

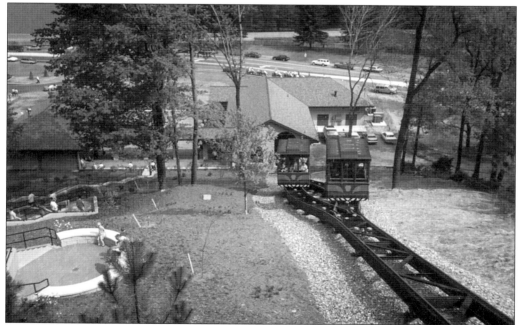

A new funicular railway transports passengers from the state-of-the-art visitors center up the mountainside to Horseshoe Curve. Renovations in 1992 eliminated the need to climb the rugged but scenic 194-step stairway up the mountainside to view the trains. Frequently two trains pass along the curve in opposite directions.

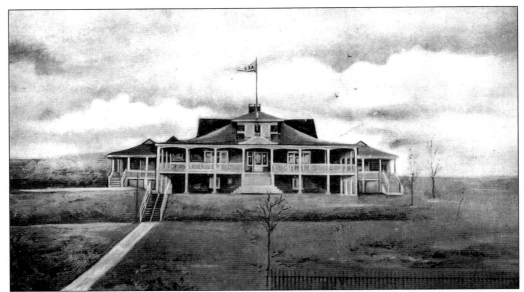

In 1878, the Pennsylvania Railroad built Cricket Field Clubhouse as a recreational facility for railroad employees and their families. Located on Chestnut Avenue and First Street, the clubhouse was the scene of many activities. English immigrants brought the game of cricket to Altoona, hence the name. Golf, tennis, baseball, and football also had their turn. In the 1960s, Cricket Field became the Cricket Shopping Center.

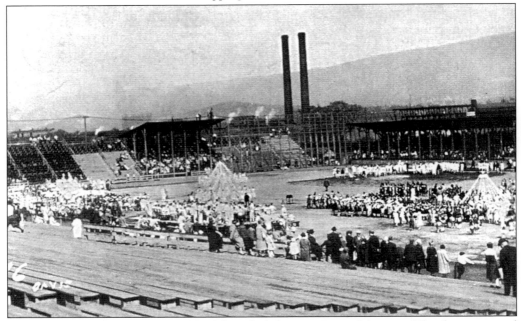

Annual events at the Cricket Field Club included a May Day celebration. Bleachers surround the field, and foundry smokestacks form the background. This playground was once a farm, which supplied vegetables to railroad personnel. The field was landscaped by the railroad, and its heyday lasted from 1900 to 1930. It accommodated 3,500 people and hosted baseball great Babe Ruth. The field also served as home field to the high schools, c. 1907.

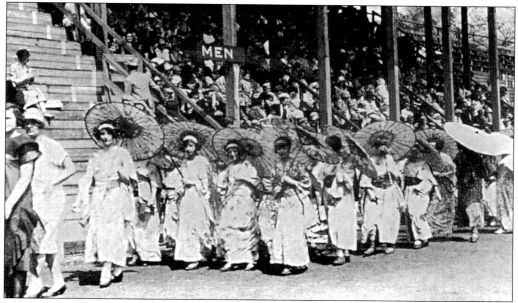

Performers carrying parasols proceed with their production at Cricket Field in 1927. The highlight of the year was the annual Tournament Ball. The young women had a dance card, or booklet, that had spaces for listing a partner for each dance. In 1909, some 575 people attended the ball and waltzed to such numbers as "Moonbeams," from *The Red Mill*, and "Shine on Harvest Moon," the barn dance.

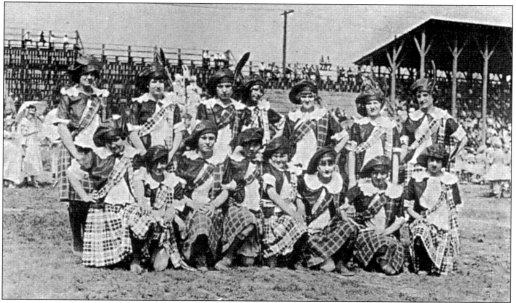

Players in kilts, a symbol of Celtic origin, pose at Cricket Field. Many of those who performed at events such as this one were railroad employees and their families. The huge stadium accommodated all the fans wishing to attend. Movie stars Mary Pickford and Douglas Fairbanks sold Liberty Bonds at Cricket Field. Always ready to enjoy a good time, Altoonans are adept at creating their own fun and working well together.

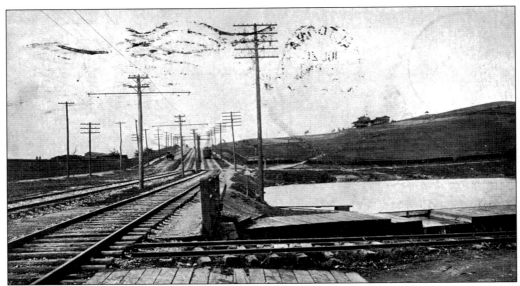

A westward glance from Juniata along Fourth Avenue in 1907 features the Cricket Field Clubhouse on the hill. A tributary of the Juniata River can be seen in the foreground. The track to Wopsononock is on the right. The array of tracks on the left linked the many buildings between Altoona in the west and Juniata in the east.

One of the first diesels built in Altoona stands on the western slope of Horseshoe Curve. The Pennsylvania Railroad designed and built its own individual classes of locomotives. Initially, that work was accomplished in the Twelfth Street shops, where all repair parts were manufactured. Manufacturing machine departments were established in shops and foundries for iron, nonferrous castings, and cast-iron wheels, which became standard for cars and tenders.

The Northern Railway rolls into a whistle-stop near Altoona. The Great Northern was a product of Altoona. Many railroad-related innovations and inventions were conceived in this vast complex of buildings. The all-steel passenger car, first constructed in the maintenance shop, was released on June 11, 1906. It was followed in November 1906 by steel baggage cars and mail cars. The new industry necessitated a transformation in the shop: wood was replaced with steel.

The Mechanics Library was initially housed in a ticket office and later in the Logan House. In 1900, the library with its 65,000 volumes was relocated to the old Presbyterian church on Eleventh Avenue. At that time, it was the first and largest library of its kind in the world. The school district converted it into a public library in 1920 and moved it into the Roosevelt Junior High School, where it remained for nearly five decades.

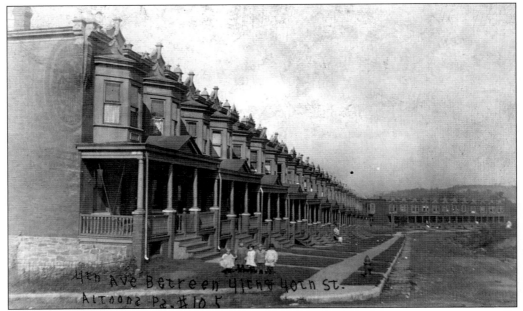

The row house community, also known as the Knickerbocker Community, was originally constructed to house employees of the Pennsylvania Railroad. William B. Gentham of New Jersey bought 42 acres and developed the land into a series of Philadelphia-style row houses in 1904. These two-story brick dwellings, with unfinished basements and transom windows, extended from Thirty-seventh Street to Forty-first Street but were not all built at the same time. Today, evidence of them remains along Burgoon Avenue.

This is the Altoona railroad station of 1965, when the Penn Central went through daily. Located on the corner of Thirteenth Street and Tenth Avenue, it was a different scene than in its original days. By the mid-1900s, Altoona was winding down as a great railroad center. Automobiles were on the rise, and trucks were transporting more and more of the freight. The Altoona Transportation Center now occupies this site.

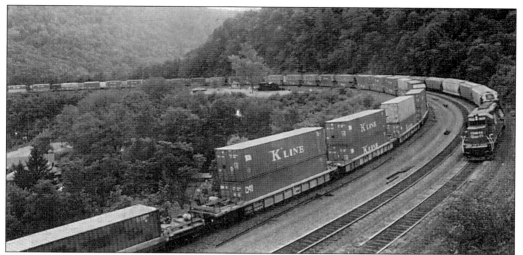

The first eastbound double-stack train rounds Horseshoe Curve in 1995. The double-stack train is a product of Conrail, a conglomerate of six already merged railroads that was founded in 1976. It necessitated the renovation of bridges and tunnels throughout Pennsylvania. A boon to commerce and industry, Conrail provides convenient, efficient service in the transport of heavy equipment, such as tractor-trailers. Amtrak came into existence in 1971 when the National Railroad Passenger Corporation initiated the operation of inter-city passenger trains.

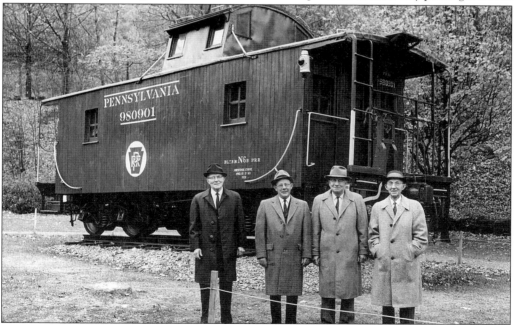

The caboose, or cabin car, serves as the conductor's office and is used chiefly by the crew and railroad workmen. A brakeman usually rides in the cupola and watches for any obstacles to the smooth running of the train. This model of a Penn Central caboose was built by the Blair County Tourist and Convention Bureau and was purchased by the Altoona Tourist Committee, which displayed it at Horseshoe Curve. The men shown are the crew members who refurbished it.

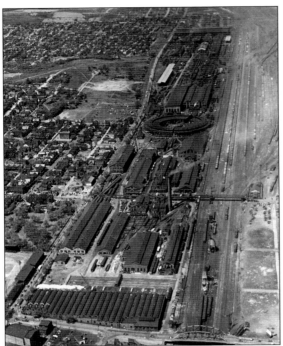

The railroad divided Altoona into two parts—north and south. North is left of the tracks in this image. The roundhouse, in the center, is where locomotives were repaired. Railroad shops were located along the route from east Altoona into Juniata. Chestnut Avenue is situated parallel to the railroad tracks. Today, this is part of the transportation facility housing stations for both buses and trains.

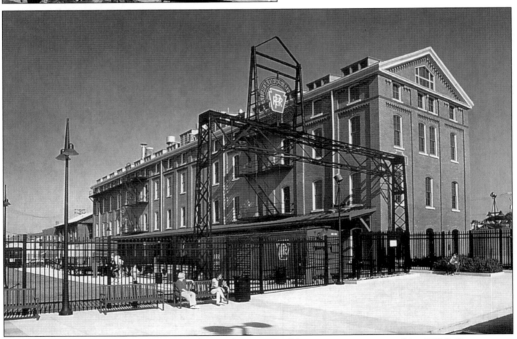

The Pennsylvania Railroaders Master Mechanics Building was constructed in 1880. It was part of the vast complex of railroad structures in downtown Altoona, where the railroad was king for more than a century. Very little is left of that network. This building, however, remains and has become one of the most complete railroad museums in the nation. The Railroaders Memorial Museum opened on April 25, 1998.

Two

INDUSTRIAL
ENTERPRISES

The *Mirror* was Altoona's first penny newspaper. Begun in 1874 by Harry Step and George Ahers, it was called the *Evening Mirror* and consisted of four columns and four pages. By 1896, a new method of typesetting, the Mergenthater linotypes, had been installed. The *Mirror* was the first newspaper in central Pennsylvania to acquire these modern typesetting machines. In 1907, the name was officially changed to the *Altoona Mirror*.

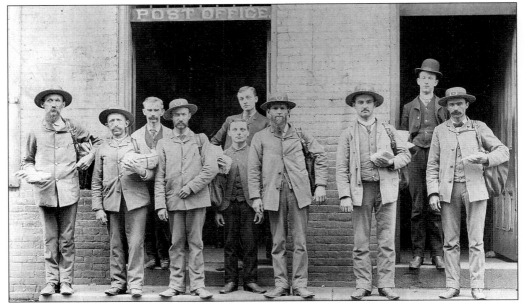

Altoona's first mail carriers are ready for action. Gathered outside the post office in 1883 are, from left to right, G.W. Amheiser, George E. Gracey, Reamer Hoke, assistant postmaster Edward O. Babcock, two unidentified men, Jacob C. Hagert, John Yeager, postal clerk Will T. Ketler, and John Costlow. The town had become large enough to employ mail carriers. In 1836, carriers received 2¢ from each person to whom a letter was delivered. Stamps were issued for the first time in 1845.

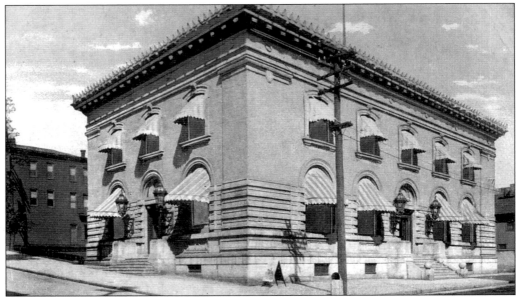

Postal service in Altoona dates to 1817. The post office was relocated each time a new postmaster was appointed. In 1901, ground was broken for a permanent home for the post office on the corner of Chestnut Avenue and Eleventh Street. The building was designed in the Renaissance Revival style in 1902. The present post office stands on the site of the Logan House.

The old city hall, Italian in style, was built in 1870. Situated on Thirteenth Avenue and Twelfth Street, it consisted of red brick with segmented arches. The building was always decorated for patriotic occasions with flags, banners, and bunting. The imposing clock tower stood aloft like a beacon and was a favorite landmark. When the building had served its term and was demolished in 1925, the tower was missed.

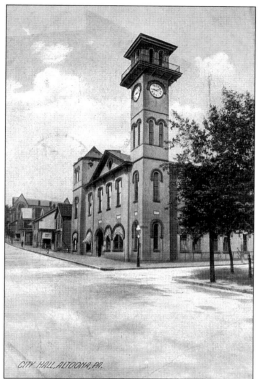

CITY HALL, ALTOONA, PA.

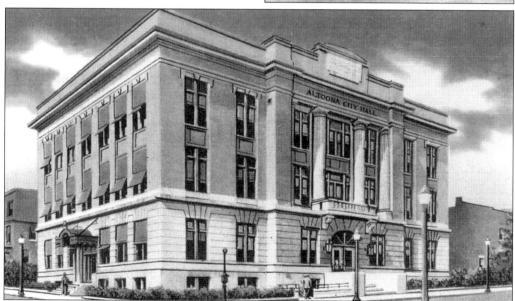

The new Altoona City Hall was constructed on the site of the former city hall in 1925 because a larger municipal building was needed for the expanding city. It was built in the Beaux Arts style, with a Rockport gray foundation of Indiana limestone, buff brick on the second and third stories, and seven skylights in the roof. Designed to incorporate municipal functions under one roof, the building has an interior that is plain in comparison with the facade.

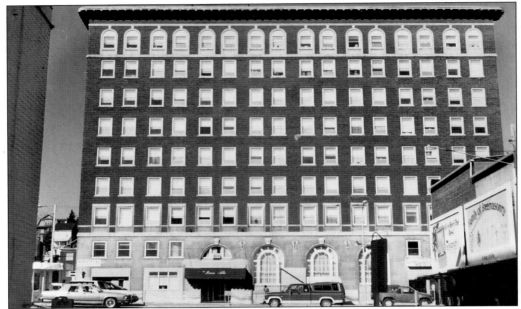

The Penn Alto Hotel was the most prestigious hotel in town. It was initially financed and built by the Blair Hotel Company, which wanted to construct a spacious hotel in Altoona. It was designed in the Italian Renaissance style in 1921. Penn Alto symbolized the civic spirit of the 1920s. Initiated by the newly formed Altoona Chamber of Commerce, the hotel was an attempt to establish a convention center in the city. The chamber recognized the need to diversify the city's economy.

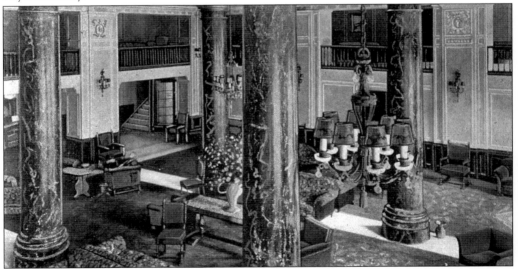

The lobby of the Penn Alto Hotel was luxurious. It was a universal meeting place, with its tranquil and charming decor. The hotel also featured a number of special rooms: the English Lounge, reminiscent of a British pub; the Logan Room, which accommodated 500 patrons and was renowned for its historical banquets and meetings; the Lincoln Room, which catered to small groups; the Continental Ballroom, where many a graceful waltz and lively Charleston were performed; and the Coffee Shop, a favorite place for breakfast and lunch.

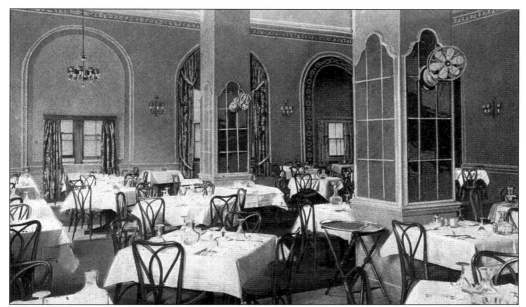

The Penn Alto Hotel has been placed on the National Register of Historic Places for its architectural significance. It was lauded for conveniences such as an elevator, bellhops, and valet parking. Chauffeur-driven limousines transported men dressed in tuxedos and women in gowns to dances held in the Continental Ballroom. Salesmen arrived almost nightly. Political figures, railroad personnel, ball players—dignitaries and others—all roomed at the Penn Alto.

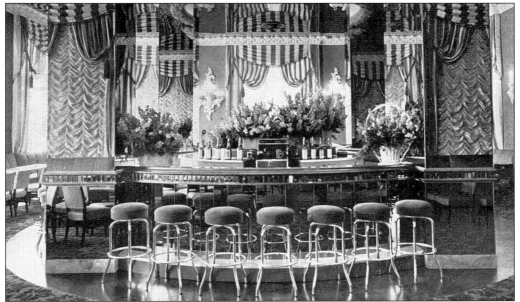

The Penn Alto Hotel, located at 1120 Thirteenth Avenue, accommodated guests in its 275 rooms on 10 floors. The hotel was launched during an era of peacetime. The flapper age was in, and knickers sold for $1. *The Four Horsemen of the Apocalypse* was playing at the Mishler Theatre when the Penn Alto opened on September 8, 1921. Two days of banquets and entertainment followed. In 1947, during a refurbishment, the circular bar was installed.

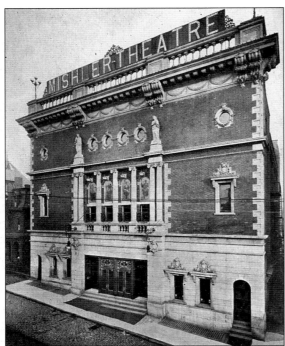

The Mishler Theatre opened on February 15, 1906. Built by I.C. Mishler, the theater was destroyed by fire in the first year. Mishler had it rebuilt by crews working eight-hour shifts under the direction of P.J. Finn. It was completed in two months' time and reopened on January 21, 1907. Dedicated by Robert S. Murphy of Johnstown, lieutenant governor of Pennsylvania, the Mishler brought live entertainment to Altoona. The Mishler has recently returned to live performances and is listed on the National Register of Historic Places.

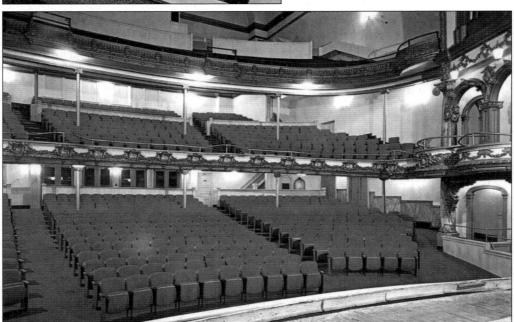

The Mishler Theatre hosted the greatest artists of the theatrical and concert worlds. In the 1930s, it featured actor John Wayne, showman Clyde Beatty, and movie star Anita Page. Admission was 25¢ for adults and 10¢ for children. In 1931, the Mishler was added to a chain of motion picture theaters and, in 1965, it was sold to the Blair County Arts Foundation. The theater was restored in 1968 as a center for the performing arts, with a seating capacity of nearly 1,000 people.

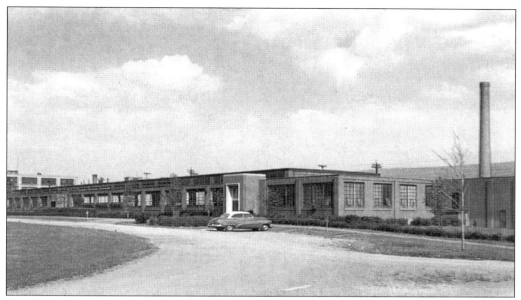

The Butterick factory was established on Beale Avenue in 1947. The first sewing patterns were shipped in April 1948. The company was originally founded in Massachusetts in 1863. Ebenezer Butterick capitalized on an idea his wife presented to him: the concept of standardized patterns. He discovered that tissue paper patterns were most feasible to fold and ship. He standardized women's dress patterns in 1866. Previously, women took old worn dresses apart to use as models. From a small beginning, the company developed into a worldwide operation.

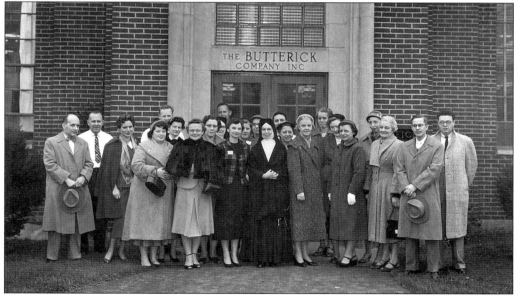

A group of educators visits the Butterick factory. Among them are two Sisters of St. Joseph and teachers from Altoona High School. Due to the acquisition of Vogue Patterns in 1961, a new 60,000-square-foot addition to the main plant was added in 1965. The plant size became 150,000 square feet and included a variety of departments in which technical skills were required. See and Sew patterns were introduced added to the product line in 1977.

Benzel's pretzels (Bretzels) have been available since 1911. German immigrant Adolph Benzel arrived with his family, all his worldly possessions, and a treasured old-world family recipe for pretzels. He chose Altoona as the site for his pretzel bakery. The business grew and expanded several times. Built on family tradition and customer loyalty, the business operates from its 70,000-square-foot factory, which offers tours and an observation area.

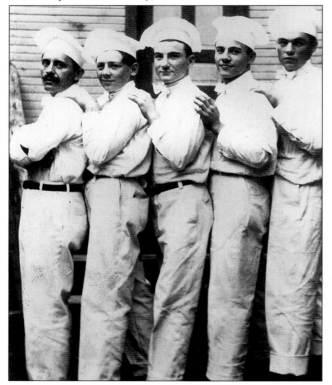

Five of Benzel's prized bakers enjoy their work. In 1948, Adolph Benzel's son George Benzel became the owner of the business. Production continued to increase and, in 1981, Adolph Benzel's two grandsons opened the most modern pretzel bakery in the world. Ninety years after the small beginning, the same recipe is still used in the production of 18 million pretzels a day.

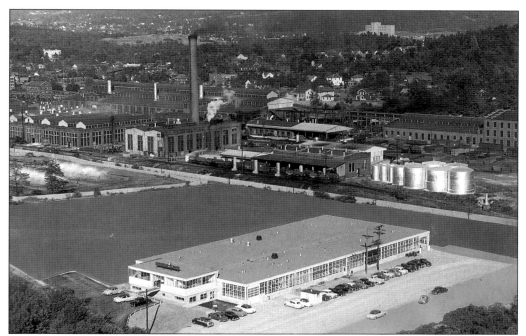

Butcher & Hart Manufacturers provided employment for servicemen returning from World War II. It was among the "Jobs for Joes" businesses that were brought into Altoona after the war. The company initially produced nuts and bolts used in other manufacturing plants. Note its close proximity to the railroad yards. The veterans hospital rises in the background.

Sylvania was a "Jobs for Joes" plant that was established in Altoona after World War II. Sylvania made radio and electrical tubes, electrical bulbs, and fluorescent lights. In later years the company expanded.

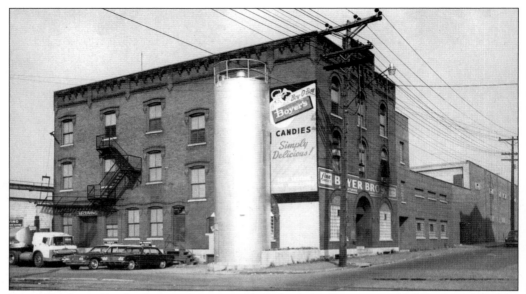

Boyer Brothers Candy Company was established in the basement of William and Robert Boyer's home on Thirteenth Street. The excellent quality of their product became widespread and rapidly outgrew the basement factory. They relocated in a double-dwelling house and, by 1939, the Seventeenth Street factory became a reality. Boyer Brothers had developed a complete line of holiday candies. They came up with a new and unusual candy called the Mallow Cup. Daily production reached 200,000 five-cent Mallow Cups in eight hours.

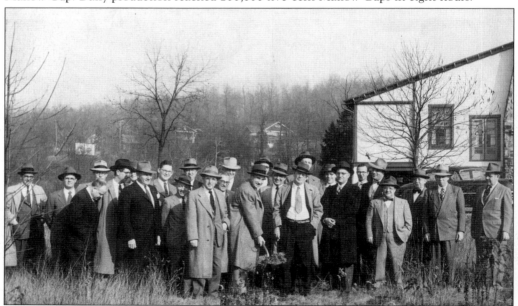

Sidney Schor, president of the Sydney Chairs Company, breaks ground for the company's new factory on November 10, 1953. The plant was completed in 1954 and produced furniture for many years. The men shown are members of the board of directors of Altoona Enterprises. To the left of Schor is D.D. Devorris, president of the industrial committee, and to the right is George C. Kelchner, president of Altoona Enterprises.

Frank Dixon founded a truck manufacturing business in Altoona. In 1921, contractor J.A. Elder purchased this truck. Dixon retired in 1959, and his last truck is in the Swigart Museum among the vehicles that have made American automotive history.

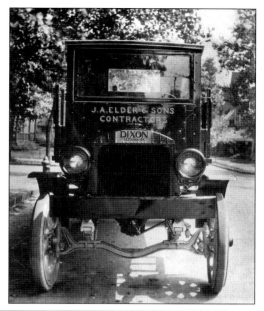

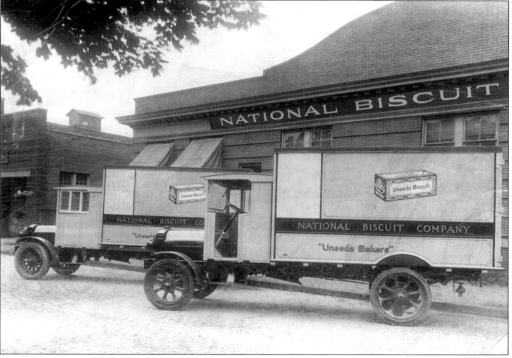

Frank Dixon's delivery trucks were popular during the Depression years. Bakers bought the trucks to deliver this healthful and popular product, Uneeda Biscuits. The local truck maker designed various styles of trucks to meet the needs of his customers. The National Biscuit Company was popular. In 1902, Christmas trees were decorated with a newly invented idea, Barnum's animal crackers. Each of the 22 cookies represented a different animal and helped to popularize P.T. Barnum and his circus.

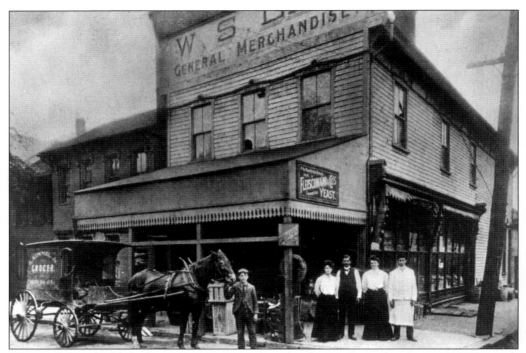

Warren S. Lee established a grocery store for the sale of general merchandise at 1300 Seventh Avenue on April 1, 1873. Realizing that there was a need for wholesale distributors, Lee relocated to 1117 Eighth Avenue and became a wholesale food distributor. His merchandising career spanned nearly half a century. In 1914, his son Walter Lee began working with him and, in 1919, took over the business. He built it into a vast distributorship serving most of central Pennsylvania.

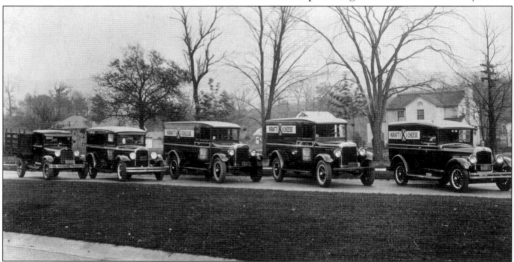

Kraft Cheese became a popular product in mid-20th century. Walter Lee served as a distributor for Kraft. The cheese products came in a variety of shapes and sizes. Some cheeses were from overseas, and others were American. In loaf form alone, there were pimento, Velveeta, brick, old English, and Swiss. Kraft also advertised "dinners that cook in seven minutes" and sponsored a weekly radio broadcast of music.

At Jake Stein's tobacco shop, the owner, left, and
Edward Hartle, right, chat with friends. The shop
was located beside the First National Bank on
Eleventh Avenue and Twelfth Street in 1898.
The shop advertisements include one for "segars."
Jake Stein shared the building with tailor
J. Snyder. Note the people upstairs (probably
living quarters) enjoying the chance to pose for
the camera.

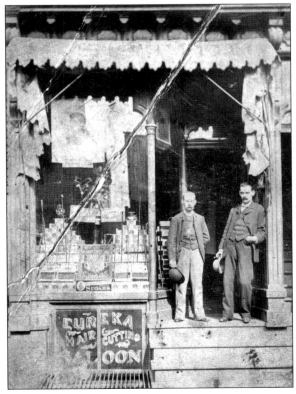

A barber in town was also a saloon
keeper and cigar dealer. Established
before 1900, the shop served the
railroad workers. Note the draped
awning. The sign advertises Eureka.
Vacuum cleaners were invented in
1865. In 1909, Murray Spangler, the
janitor at Hoover Harness and
Leather Factory, invented the electric
vacuum. Eureka followed in 1912.
The original models are preserved in a
Vintage Vacuum Cleaner Museum.

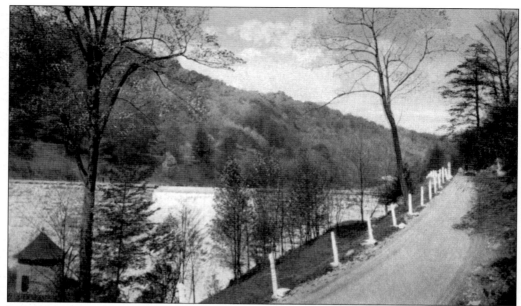

In earliest times, water was procured from wells. In 1859, a water company was formed and a system of waterworks was established. The city outgrew the system that was on Twelfth Street, and reservoirs were built in the mountain along William Penn Highway. The highway is now the westbound lane known as old Route 22. Note the small water tower on the left. Pipes were laid underground to the city.

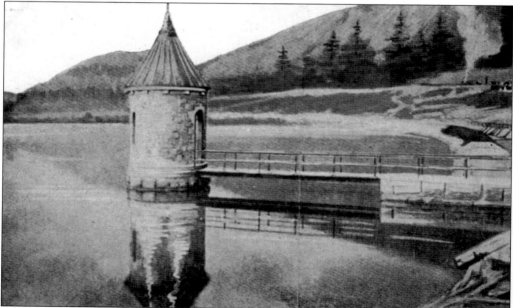

The intake tower at Horseshoe Curve dominates the landscape in the mountain reservoir. The city expanded so rapidly that it was necessary to construct a reservoir part way up the mountain, at Kittaning Point, with pipes laid underground to the city. The reservoir was extended through the years to form what looks like multiple lakes at Horseshoe Curve.

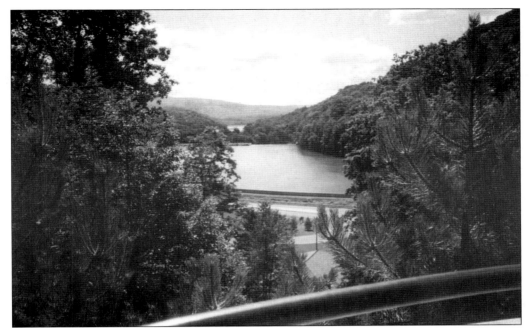

What appears to be a picturesque lake is, in reality, the Altoona Reservoir, which supplies water to the city. This view was taken from the top of Horseshoe Curve, which links east with west.

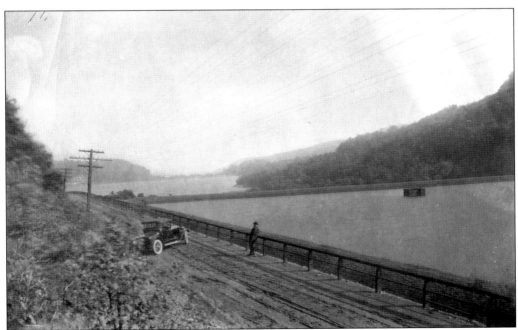

A man enjoys a peaceful moment beside the water, part of the Altoona Reservoir. The yet unpaved road skirts Horseshoe Curve, and the two-passenger car features a rumble seat, which lifted out in back. The rolling mountains of the Altoona area form the background.

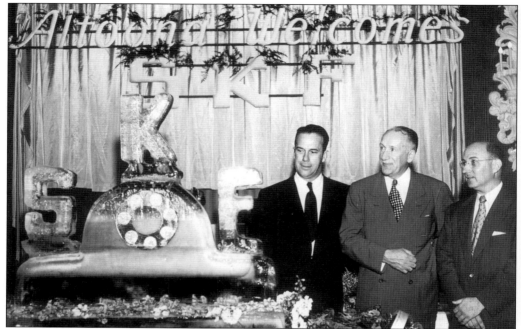

SKF is the world's leading manufacturer of rolling bearing solutions. Founded in Sweden in 1907, the company emerged from Sven Wingquist's solution to a misaligned drive shaft in a textile mill. Wingquist's invention of a double-row self-aligning ball bearing was the first of many that SKF has provided to industry, among them the current life calculation methods used worldwide and 2,200 other patented advancements.

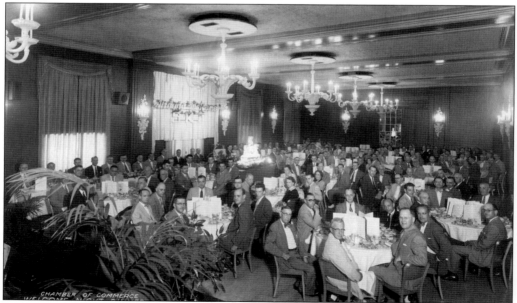

SKF was established in an abandoned shirt factory in Altoona in 1952. The initial operation of the plant was grinding and assembly. On June 26, 1952, the Altoona Chamber of Commerce gave SKF a welcome dinner at the Blairmont Country Club in Sylvan Hills.

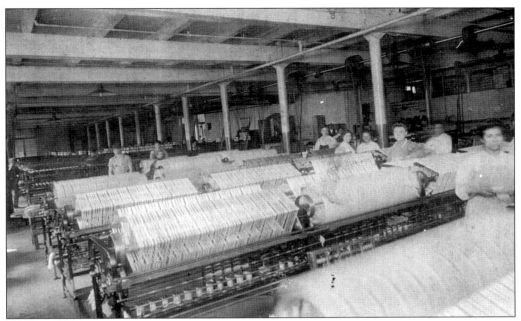

The Schwarzenbach-Huber Silk Mill was located on Eighth Avenue at Twenty-fourth Street. Silk symbolized luxury and elegance in ladies' raiment. It was the aristocrat of fabrics. Schwarzenbach was founded in Switzerland in 1829 and became the world's premier silk firm. Schwarzenbach-Huber mills were established in many countries and were recognized as the most influential factor in silk manufacture. It made its way to Altoona in 1881. This enterprise later became Paragon Textile and, in 1941, the Puritan Knitting Company.

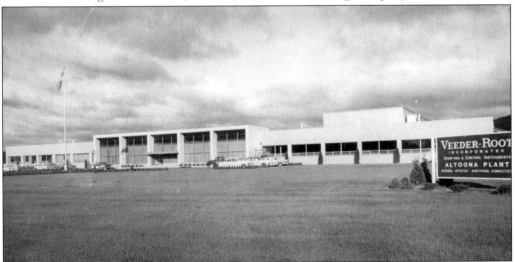

Veeder Root specializes in petroleum and fuel management processes. In 1866, the Root Hinge Company was founded in Bristol, Connecticut. It manufactured counting and measuring devices. In 1895, Curtis Veeder, founder of the Veeder Manufacturer Company, invented the cyclometer to record mileage on a bicycle. In 1928, the companies merged to form Veeder Root of Hartford, Connecticut. In the 1930s, a customer installed a counter into his gasoline pump, and that simple step led Veeder Root to become a leader in petroleum technology.

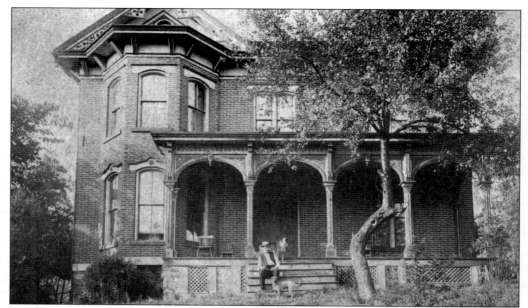

James and Harry Gwin established a surveying and civil engineering business in the late 1800s. They built this homestead, which was later donated to the Penn State campus. Lewis L. Gwin, a descendant, initiated the first engineering business in Altoona in the 1930s. Known today as Gwin, Dobson and Foreman, the company provides civil, environmental, mechanical, electrical, and structural engineering services for public works and other projects.

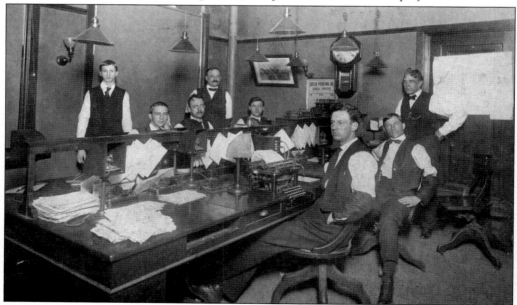

The Western Union Telegraph Company was established in Altoona at the beginning of the 20th century. In April 1907, this office was located on Twelfth Street and John H. Wilson was manager. Invented by Guglielmo Marconi, the wireless telegraph was a fast medium of communication in the days before the telephone. A series of dots and dashes tapped out messages from around the world. In 1880, the first telephone exchange was established in Altoona.

Three

THE GATEWAY CITY EMERGES

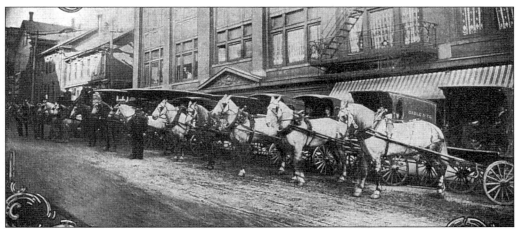

Gables Department Store employed a team of delivery personnel to assure prompt delivery. Thomas McGough was director. Initially, the store hired three cash boys and a pushcart. The business grew rapidly and, by 1914, it had 15 horses and carts to deliver merchandise throughout the city and beyond. Hitched to their carts, Gables faithful horses stand ready for the next delivery.

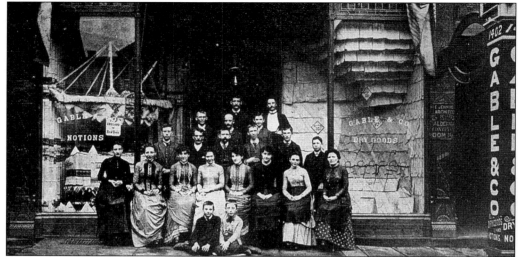

In 1884, Gables was founded in a single room by William F. Gable. In 1891, Gable constructed this Victorian Neoclassical building between Eleventh and Twelfth Avenues. It was a forerunner of our department stores today. Sometimes called the Daylight Store, and other times the People's Store, Gables featured dry goods on the first floor and household furnishings, glassware, and china in the basement. Millinery, cloaks, and curtains were on the second floor, and the third floor was used for storage.

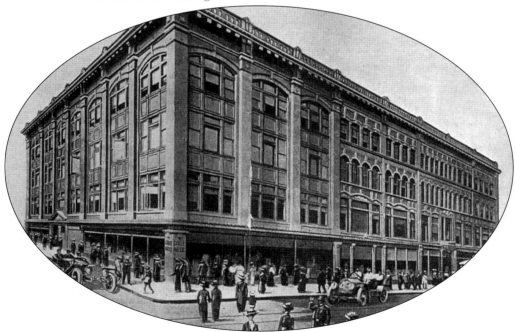

Gables Department Store displayed the merchandise in six beautiful windows of French plate glass. A copper-lined balcony and decorated second-story front completed the exterior decor. The 120-by-175-foot building housed over 40 departments. By 1913, Gables was the largest and most complete department store in the state. Founder William F. Gable was active in many community affairs.

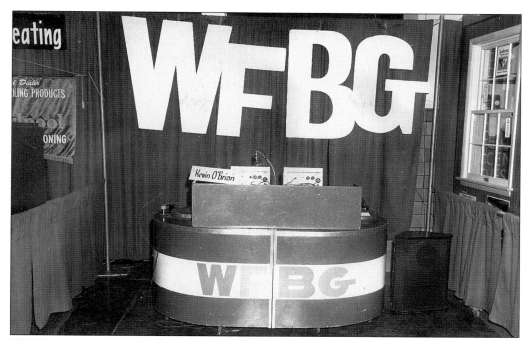

WFBG was born when William F. Gable bought the original WGAW radio station in 1923. He installed a 100-watt transmitter in his crystal studio. WFBG operated in the public interest. It was dedicated to the people and backed every worthwhile project, be it civic, fraternal, or religious. In 1940, the station's power was increased to 250 watts, and a great step was taken when WFBG became affiliated with the National Broadcasting Company (NBC).

WFBG radio brought news of the day during World War II. In 1948, the station extended into the FM field. In 1952, William F. Gable was granted a television license to operate WFBG-TV. On March 1, 1953, the first regular broadcast was aired. In 1956, Gable sold the station to Triangle Publications, which owned and operated it until 1972, when it was purchased by Gateway Communications.

49

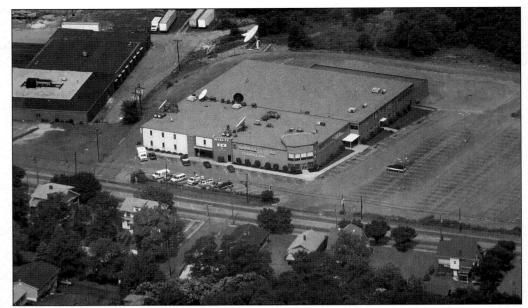

WTAJ-TV became the station's new call letters, reflecting the cities it served. The 2,000-square-foot studio and office building is located on Sixth Avenue beside the Benzel Pretzel Bakery. It has served as the television studio since mid-century. The station has been cited as media's third generation. Television joined the newspapers and radio in their efforts to entertain, educate, and inform the people of Altoona. In 2000, the station was bought by SJL Northeast.

WTAJ-TV celebrated its first 25 years of broadcasting in 1978. Open house included a display of photographs and nostalgic memorabilia. The station received an awards citation from the Roman Catholic Diocese of Altoona-Johnstown. In 1956, when the station became an affiliate of CBS, it offered viewers a wider range of programs and included local news and shows, and CBS and NBC offerings. NBC programming was phased out in the early 1960s, at which time TV-10 remained an affiliate of CBS.

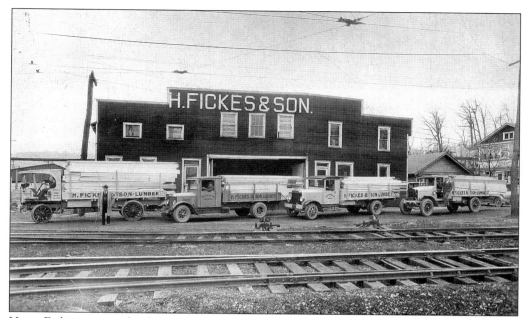

Harry Fickes set up a lumbering business in the late 1890s. The surrounding mountain ranges contained many species of lumber. By 1896, planing mills constituted the leading industry in Altoona, with a total of 12 in operation. Much of the timber went into railroad ties and was used for paper needed by the many industries in town. In the early years, it also was used for boxcars and early passenger trains, which were wooden.

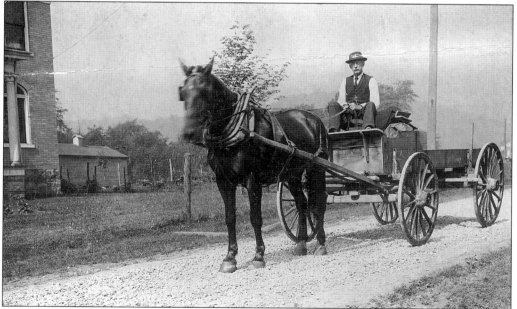

Harry Fickes takes his horse as he checks out the possible timber in the surviving woods around Altoona. Logging on the Juniata River became prominent because of the huge acreage of vital timber. Nearby hamlets in Northern Cambria supplied much of the wood that was shipped to distant ports. Timber was a necessity in an industrial town such as Altoona.

Wolf Furniture had its beginning when Charles E. Wolf opened the first City Furniture Store in 1902. It was located in the Quandt and Cherry building on the corner of Green Avenue and Ninth Street. In 1914, the company moved to spacious quarters on Eleventh Avenue and Fifteenth Street. Wolf fell victim to the flu epidemic of 1918 and his wife, Annie Anderson Wolf, became the sole owner. Her sons, George and John, became managers.

Wolf Furniture in Altoona was the parent of 11 stores outside the city. The Altoona store was designed with five floors. The fifth floor was unusual for its modern daylight effects under which colors and fabrics could be easily inspected by customers. A large range of colorful products were conveniently displayed on all five floors, with each floor devoted to a different decor. The fourth floor displayed a Colonial clapboard house.

The Phoenix Fire Department was one of many small firehouses throughout the city in 1896. The clang of a bell, shrill of a whistle, or even the ringing of a church bell at an unusual time brought the firemen to the firehouse to obtain their hand-drawn cart. With all departments combined, the total firefighting force numbered 400 men. Their trademark was red shirts and black boots. Individual fire departments were supported by the people.

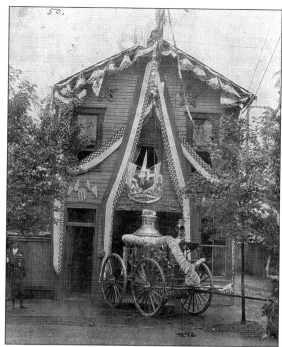

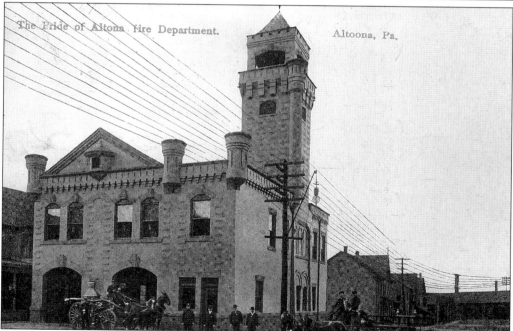

Nine fire departments were established throughout Altoona after city water became available. In 1895, the city passed an ordinance providing for a paid fire department. In May 1895, the new department was installed, with Fire Chief J.N. Tillard and 35 men. They operated with three steam fire engines, five hose carriages, one hook-and-ladder truck, 700 feet of hose, and 14 horses for hauling engines. The police patrol responded to all fire alarms.

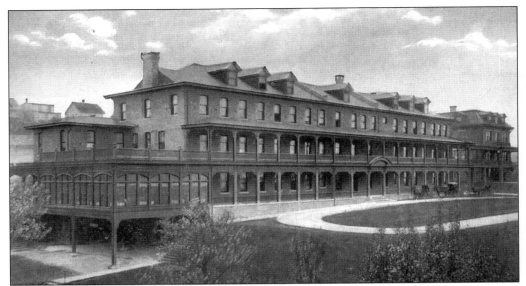

The Pennsylvania Railroad donated land and money for Altoona General Hospital, which opened on January 1, 1886, in a two-story brick building on Chestnut Avenue. The hospital had 24 beds and initially served only railroad personnel. Many casualties that occurred on the railroad needed immediate medical attention. A total of 113 men were treated at the hospital the first year. Women were admitted for the first time in 1887. The nurses residence, constructed in 1905, is on the right.

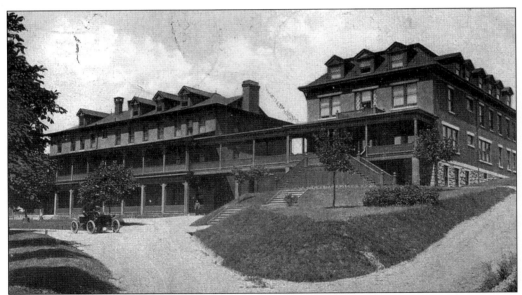

Altoona Hospital grew rapidly from the beginning. The first medical staff members were appointed on November 11, 1885, with Dr. John Fay as chief of staff. The first ambulance was provided on July 26, 1886. The number of patients increased rapidly and a second story was added to the main building. By 1893, a third story was opened. The next expansion came when wings were added. Altoona Hospital served not only the city of Altoona but also the surrounding hamlets.

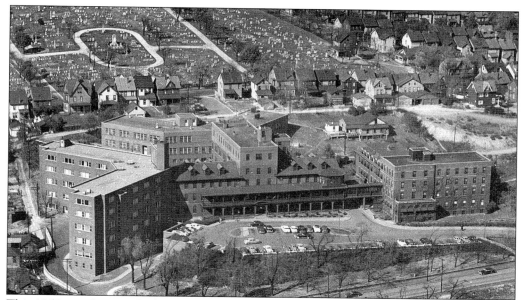

This 1953 aerial view of Altoona Hospital clearly indicates a tremendous expansion. By mid-century, the facility had become a multibuilding complex. Additions were added to additions until it was necessary to modernize the entire facility. The hospital continued to implement many new medical services as it kept pace with medical technology. Fairview Cemetery is visible in the background.

Altoona Hospital has evolved into a tall tower of 14 floors. Completed in 1980, it dominates the Altoona landscape. Project architects were Judy Coutts and Kathleen Muffie Witt. The tower houses a 354-bed facility served by 220 physicians. The hospital has its own rapid response stroke team, hyperbaric oxygen chamber, and open magnetic resonance imagery (MRI) system.

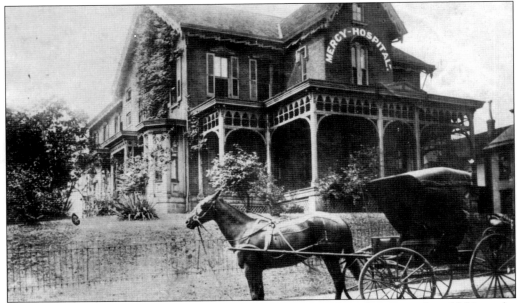

Mercy Hospital was originally the home of Thomas McCaulley. Constructed in 1866 on the corner of Eighth Avenue and Twenty-sixth Street, the building was bought by the founders of Mercy Hospital from Martin F. Orner in 1910. Necessity called for a second hospital in Altoona. On July 14, 1910, care of the sick began when Mercy officially opened with 15 physicians and 6 nurses. With the hope of asking a congregation of Sisters to staff the new hospital, it was named Mercy Hospital.

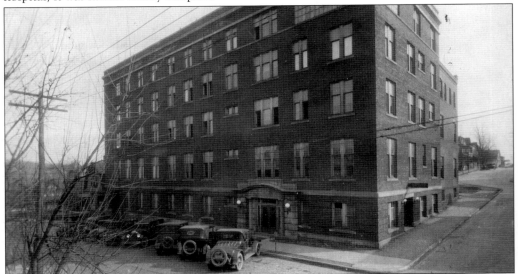

Mercy Hospital housed the most modern equipment of the day. A laboratory and an X-ray machine were paramount. The number of patient beds steadily increased, and major building expansions were undertaken. The Thomas McCaulley house was nearly lost in the maze of buildings that gradually became Mercy Hospital. By 1917, a wing had been added and the front porch removed. A few years later, an addition was constructed at the rear of the building. Mercy had become a thriving institution, noted for kindness, generosity, and friendliness to patients.

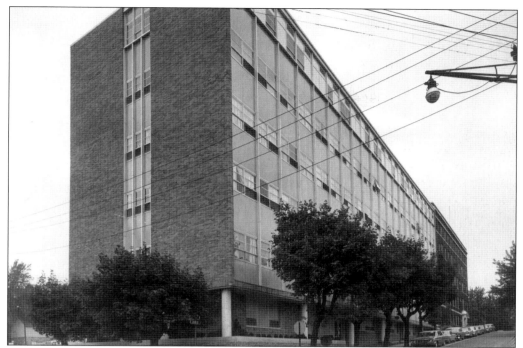

In 1927, the capacity of Mercy Hospital reached 180. In 1935, the board of trustees asked the Sisters of the Holy Family of Nazareth in Pittsburgh to staff the institution during the very difficult social and economic times. In response 20 Sisters agreed. In 1966, the Sisters sought to augment the staff with members whose values and mission were similar to their own. They found such a partner in the Sisters of Bon Secours.

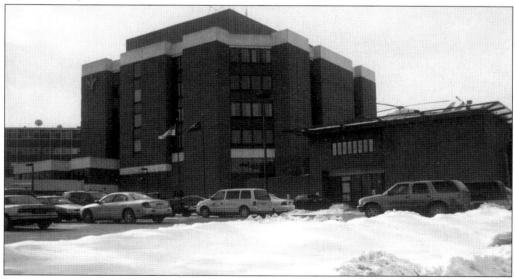

Bon Secours Holy Family Regional Health Care System Hospital grew in leaps and bounds. After many additions, the original house was demolished in 1980 and a new building replaced it. The hospital gained central registration, expansion of the emergency center, creation of a new surgical suite, and outpatient procedure rooms.

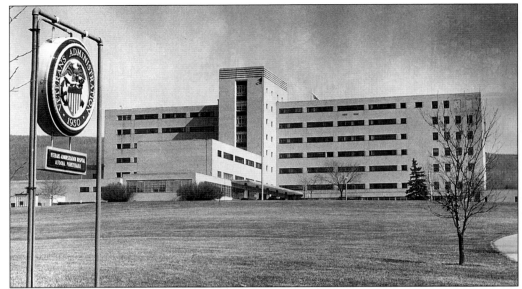

The J.E. Van Zandt Veterans Hospital is a general medical and surgical facility serving veterans of the armed forces. It was established in 1948 in answer to the need for such a project in central Pennsylvania. Congressman James E. Van Zandt, an Altoona native, spoke at the hospital's dedication in November 1950. The site covers 23 acres and is dwarfed by Bush Mountains in the background. The hospital's seven stories contain 174 beds, plus 20 for nursing care.

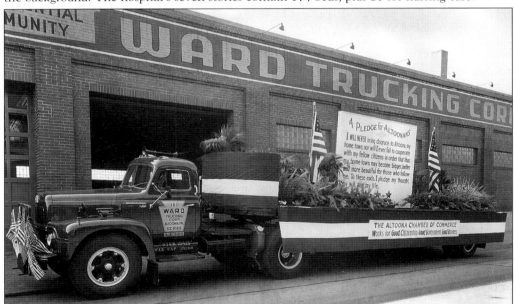

"Ship the Ward Way" is synonymous with the Ward Trucking Company. William W. Ward established this fast and dependable service in 1931. The freight terminal and office were initially located on the corner of Second Avenue and Seventh Street. Ward Trucking grew rapidly from a single truck to an entire fleet of vehicles. Tonnage increased, and the business expanded to meet the needs of wholesalers, retailers, and manufacturers in central Pennsylvania and beyond.

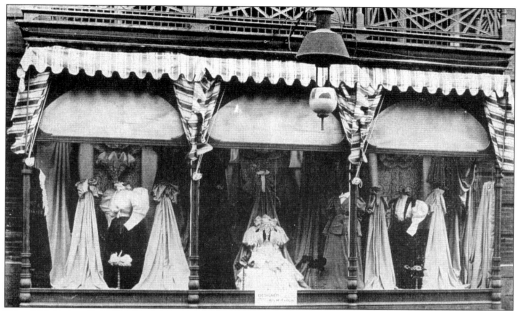

The J.T. Baltzell Store was Altoona's first department store. It was located at Eleventh Street and Eleventh Avenue. J.T. Baltzell, a community-minded individual, was instrumental in paving the streets of Altoona. He was part owner of the Opera House of Altoona. He sold his Victorian mansion to the University Club in October 1907. The club promoted educational interests in the community. Among other activities, the club sponsored annual high school oratorical contests.

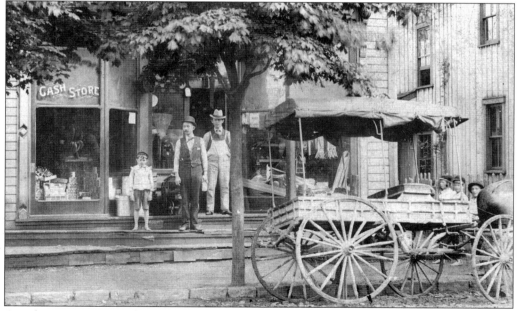

A cash store was a novelty before 1900. Employees who worked on the railroad were expected to buy their necessities in the company store. This practice was short-lived in Altoona, where retail businesses were prevalent.

Rothert's Department Store was founded by Oliver Rothert of Baltimore in 1907. Constructed of gray brick, it featured terra-cotta keystones. The edifice represented a new turn-of-the-century scale of building. It was situated on the corner of Twelfth Avenue and Twelfth Street near the Mishler Theatre. Many homes in Altoona were furnished by Rothert's, which carried an elegant selection of furniture. This photograph was used as a Christmas greeting card in the late 1930s. The building was razed in the 1980s.

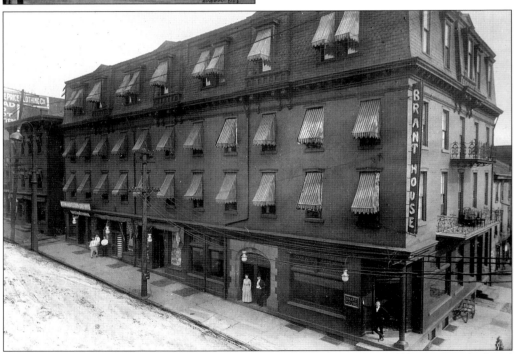

The Brant House was located on the corner of Tenth Avenue and Twelfth Street. The hotel was built in 1867 by Caroline Schenk and Jacob Alleman. It flourished for many years and served the Gay Nineties era with its gaslights, horse-drawn carriages, and Victorian opulence. By 1913, the need for hotels was diminishing. The building was sold to the Pennsylvania Railroad, and it was razed in 1935.

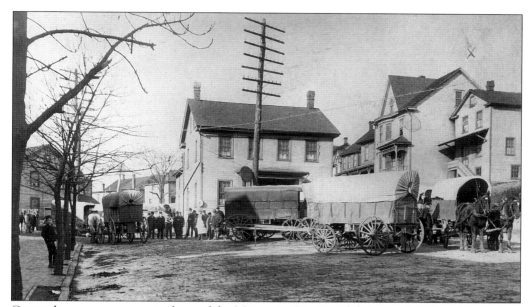

Covered wagons converge in front of the Mountain City Hotel, bringing families with all their belongings. Patrons gather outside the hotel, located on the corner of Sixteenth Street and Washington Avenue. The D.C. Imler Meat Market is on the left, and Strohman Bakery is on the right. The hotel, which had easy access to the railroad, was under the proprietorship of J.D. Smith. It was originally the private residence of the Smith family.

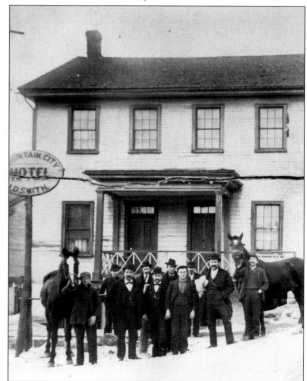

The Mountain City Hotel served railroad personnel and visiting businessmen alike. In the late 19th century, hotels were a necessity in town. In a thriving business community, families resided for months in hotels while waiting to move into their newly constructed homes. The Mountain City Hotel was known for having clean, comfortable rooms.

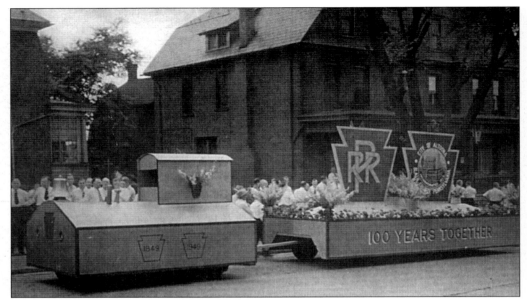

The Pennsylvania Railroad centenary float makes its way through downtown Altoona in a parade that was part of a celebration marking 100 years since the rails first reached the base of the mountain. The week-long celebration held in August 1949 included not only parades but also excursions, a model air show, baseball games, a pageant, tournaments, horse shows, block dances, and fireworks. A U.S. Navy blimp flew over the city from Lakehurst, New Jersey.

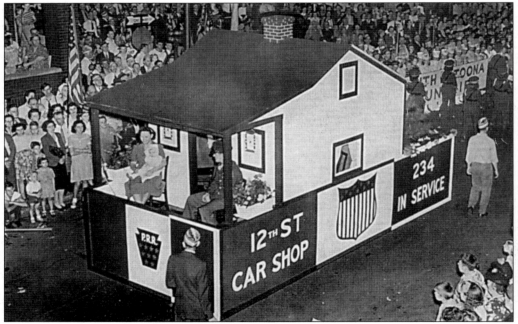

The Twelfth Street Car Shop designed this float for the parade honoring World War II veterans. Altoona jubilantly welcomed its servicemen home. The United States entered World War II after the Japanese attacked Pearl Harbor on December 7, 1941. The war, which cost many lives, ended when the Japanese surrendered on August 14, 1945.

The Altoona Board of Trade was organized in 1887. Its goals focused on the overall good of the entire community, as did those of the Altoona Chamber of Commerce, which was formed in 1905.

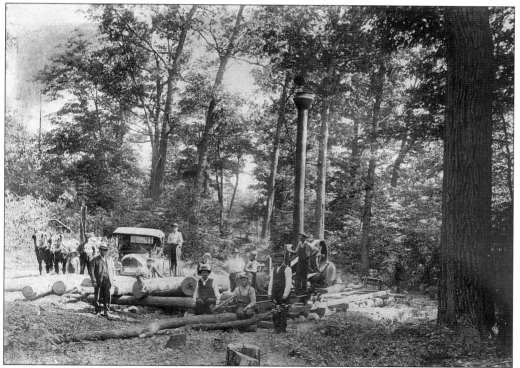

On September 16, 1915, individuals gathered at Grant McClellan's sawmill in Juniata Gap to determine the age of some of the very large trees on the property. Upon inspecting the stumps of trees cut down that day, they found that some contained as many as 336 layers of bark. Forests on the mountain ranges consisted of many species. Each charcoal furnace took over an acre of timber per day.

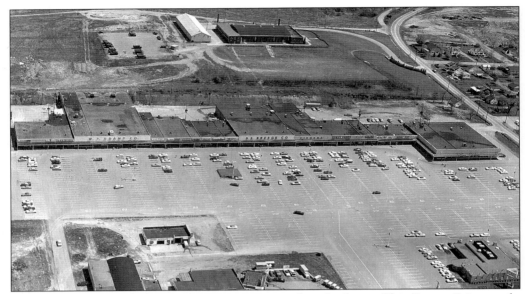

The Pleasant Valley Shopping Center was constructed on the former Blair County Fairgrounds, which later became the Driving Park. The National Guard Armory is in the background. Penn Hardware, Fishers Clothing Store, Lato Shoe Repair, and Thrift Drugs are among the businesses in the open mall. W.T. Grant, second from left, opened a store in Massachusetts in 1906 with no intention of further merchandising. The store's reputation grew and, by mid-century, there were 490 W.T. Grants around the country.

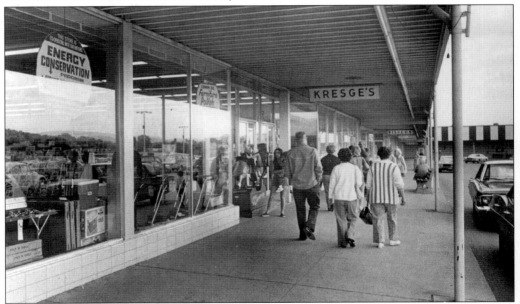

Kresges five-and-ten is featured in the Pleasant Valley Shopping Center. Sebastian S. Kresge was a salesman. He and John G. McCrory became partners and opened two five-and-tens in 1897. The stores originally sold merchandise at 10¢ or less. By 1912, there were 85 S.S. Kresge stores in the country. In 1962, the Kresge Company entered the large-scale discount retail business with the construction of the first K-Mart.

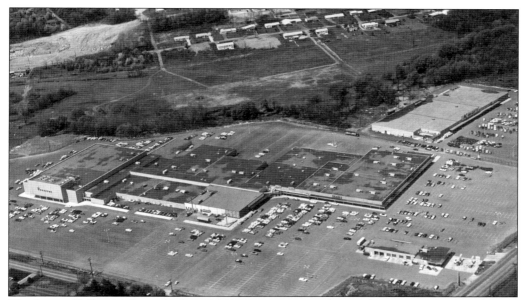

The Logan Valley Mall was built in 1960 as an open-air plaza with Sears Roebuck and a few small shops. In 1965, J.C. Penney was added. In the late 1960s, developer Crown American enclosed the plaza, completing its first mall. Hess Department Store was added as an anchor store. On December 16, 1994, half the mall was destroyed by fire, but reconstruction began immediately. Kaufman's was added, along with a vast parking garage. Today, the mall contains nearly a million square feet of space. K-mart is visible in the upper right.

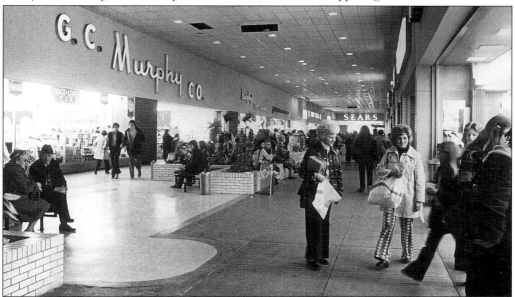

The original interior of the Logan Valley Mall featured Murphy's Variety Store. The store was established in McKeeysport in 1906 by George C. Murphy, who operated it on the principle of giving customers variety in one place. Beginning in 1908, Murphy's ownership changed a number of times and stores were opened in towns and cities, most of them close to Pittsburgh. The Altoona store was destroyed in the December 16, 1994 fire and never reopened.

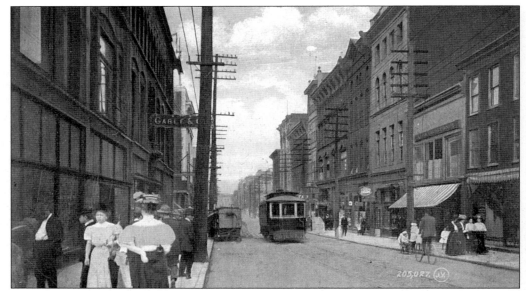

This is a glimpse of Eleventh Avenue looking east in 1910. Note Gables Department Store on the left. As Altoona's population increased, the city spread in all directions and the streetcar system became a major means of transportation. Streetcars went into operation on July 4, 1882. They were electrified in 1891 and served in that capacity until being phased out in 1954.

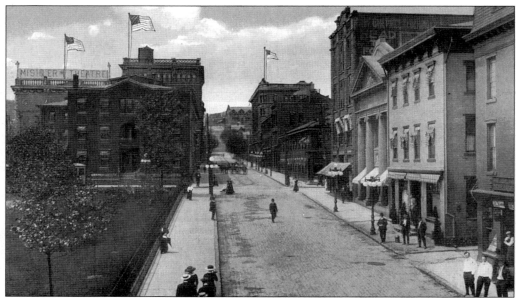

This view of Twelfth Street was taken from the bridge looking north *c.* 1900. The Bingham Hotel, Mountain Trust Company, United Cigar Store, and Altoona Tribune are visible along the busy street. One Price Clothing is on the right. It advertises "one price, head to toe." The Mishler Theatre is on the left.

Four

YESTERYEAR AROUND ALTOONA

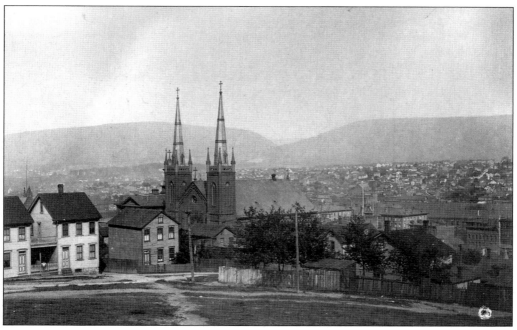

Towering 200 feet above the city are the double spires of St. John's Roman Catholic Pro-Cathedral. Located on the corner of Thirteenth Avenue and Thirteenth Street, the frame cathedral with a seating capacity of over 1,000 was dedicated in 1853. It was designated a Pro-Cathedral on May 30, 1901, when Pope Leo XIII established the Diocese of Altoona. The Very Reverend Eugene A. Garvey of Scranton was appointed as the first bishop. The new diocese comprised 6,700 square miles. Note the rolling mountains beyond the city.

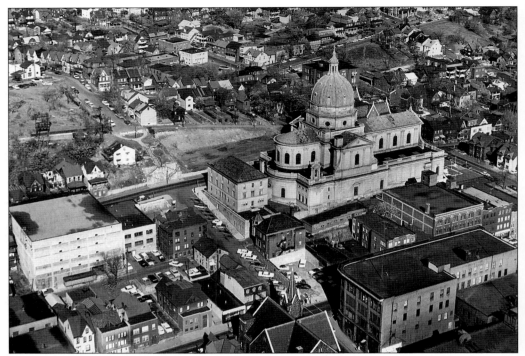

The dome of Blessed Sacrament Roman Catholic Cathedral dominates the landscape of downtown Altoona. The second bishop of Altoona, John J. McCort, arrived in 1920. Under his leadership the Cathedral of the Blessed Sacrament was constructed. Designed in Italian Renaissance style, the cathedral stands 200 feet high from floor to dome. Groundbreaking took place on September 17, 1924, and the cathedral was dedicated and opened on Labor Day 1931.

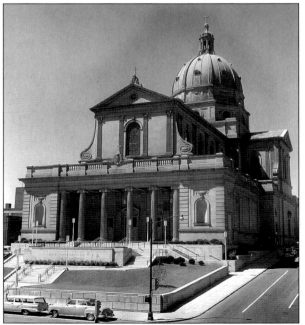

The Blessed Sacrament Cathedral was built on the site of the old St. John's Pro-Cathedral. It has retained the status of its predecessor as the city landmark and is plainly visible from all parts of Altoona. Its cornerstone was laid in 1926, but construction was temporarily delayed during the Depression. While it was being built, a hall on Twelfth Street served as a temporary house of worship.

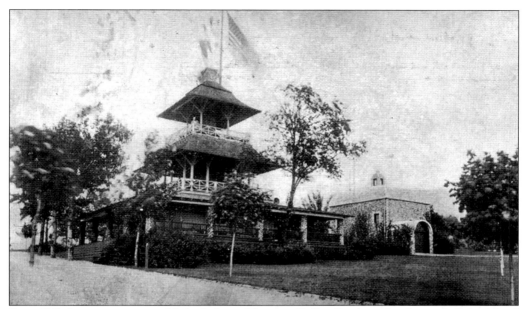

Rose Hill Cemetery was established above Pleasant Valley Boulevard—the end of the Third Avenue car line. The front 100 acres of the cemetery are in Altoona, and the remainder is in Logan Township. The first interment took place on July 3, 1905, and over the next 25 years, the number of burials reached nearly 5,000. The cemetery maintains offices in the Pennsylvania building on Twelfth Avenue. For a long time, Rest Cottage, with its high lookout tower, graced Rose Hill.

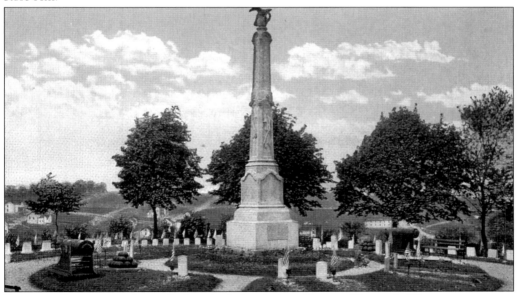

Fairview Cemetery is located directly behind the Altoona Hospital. The cemetery was established in 1857 by Rev. Henry Baker. In 1858, 16 graves were relocated from Collinsville and Union cemeteries to Fairview. Union was located on the busy corner of Eleventh Avenue and Fifteenth Street. In 1862, the highest mound was designated as the Soldier's Circle, complete with a monument. Fairview, with 15,000 plots, covers 20 acres of land.

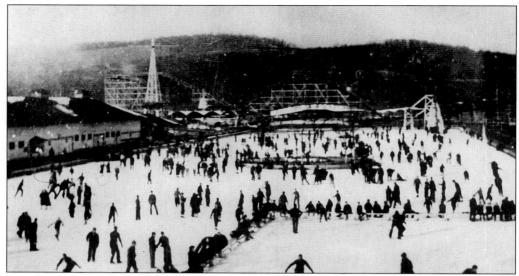

Ivyside Amusement Park was developed on what is today the campus of Penn State University. In 1920, Raymond Smith and James Gwin transformed 40 acres of land along Juniata Gap into a park for all seasons. The park featured an Olympic-sized swimming pool, surrounded by a wide boardwalk, and a massive bathhouse (left), which accommodated 3,000 patrons. It also had a roller coaster and other amusements (background). In the winter, Ivyside was converted into an ice-skating rink.

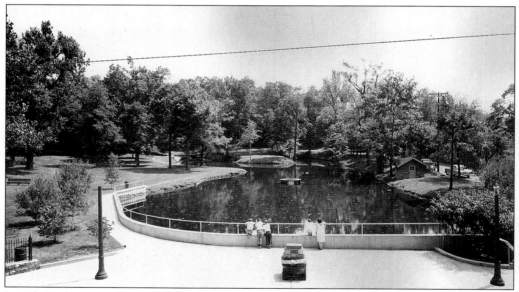

Ivyside Park operated successfully for two decades. The Great Depression and World War II took their toll, and the park phased into oblivion. In the meantime, Penn State had opened an undergraduate center in the former Webster Elementary School in September 1939. The college approached Ivyside Park owner Mrs. Raymond Smith about the possibility of the land becoming a campus. A contract was signed in 1947, and the campus was subsequently developed on the park site. In this view, the chapel is in the right foreground and the student union is across the lake.

Pennsylvania State University was founded in State College in 1855 and branched into Altoona in 1939. The new campus gave students and faculty a sense of camaraderie as they watched the new campus emerge from "Bathhouse U"—Ivyside Park. A make-do attitude prevailed. Today, there are 20 buildings on the 115-acre rustic campus, which has maintained its scenic beauty.

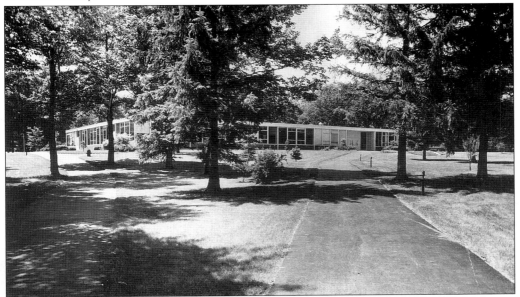

This building was constructed to house the administration of the growing campus. Initially, Penn State in Altoona offered a two-year college program. Major degree programs were added later, as well as work toward degrees in the sciences, arts, and nursing. A degree program in a combination of electrical and mechanical engineering technology—the only one of its kind in the state—was also added to the curriculum. Through its continuing education department, Penn State created a wide range of seminars for students in business, industry, and entertainment.

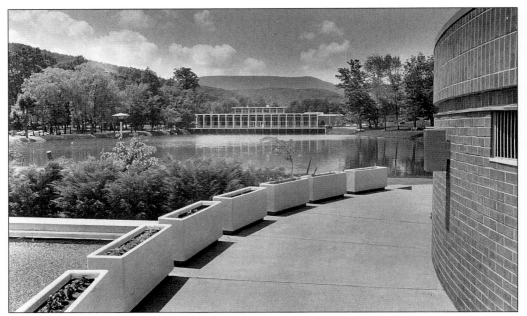

In 1948, classes at Penn State were held in the renovated Ivyside bathhouse, which was transformed into a library, 12 classrooms, biology and physics labs, and administrative offices. The Ivyside roller rink became a student union (across the water), the concession stand became a steam plant, and the world's largest concrete swimming pool became a parking lot. James R. Stine was among the first to register.

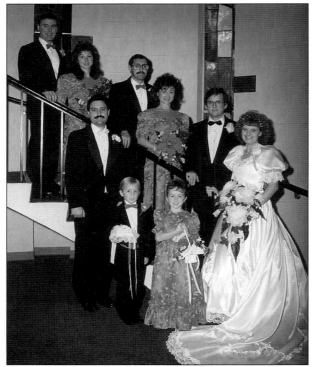

The chapel at Penn State has lent itself to many functions. On October 8, 1988, this wedding party gathered on the spiral staircase following the marriage ceremony. Members of the party, from left to right, are as follows: (front row) Dr. Harry Penny, Brian Kozak, and Stephanie Baker; (back row) Michael Baker, Rosemary Battista, David Stine, Conny Baker, and the newlyweds, Dr. Karl F. Stine and Ida Mae (Mitchell) Stine. Dr. Stine, an Altoona native, maintains a medical practice in Cresson and serves in the Altoona hospitals.

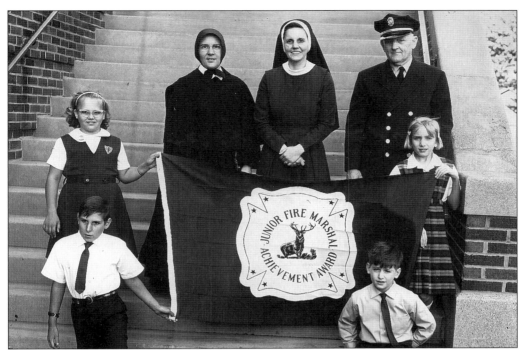

Junior fire marshals receive an achievement award in the mid-1960s. With their respective students are Sr. Marian Jeanne Evers, SC, principal of St. Leo's School (left), and Sr. Mary Lambert Hagg, RSM, principal of St. Mark's School (center). In the fall, the students went on a field trip to the firehouse during Fire Prevention Week.

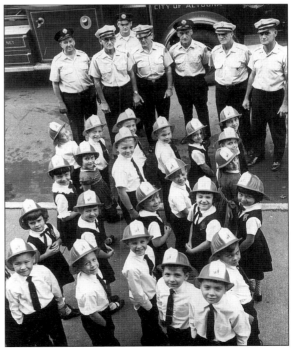

These students are proud of their new role as junior fire marshals. Fire education has become part of the curriculum in all schools. During Fire Prevention Week each October, schools hold fire drills and study fire safety and prevention.

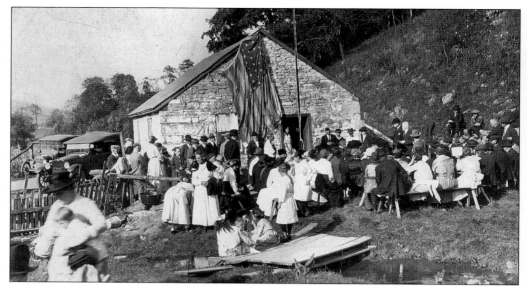

Education in Altoona dates back to 1815. At that time, a crude one-room building served as the classroom. Logs cut to clear the site were used in its construction. Known as Beale School, it later became Black Oak Ridge School. This c. 1900 photograph shows Dick School, which was typical of primitive schoolhouses. Often, these buildings were also used for church services, town meetings, and village gatherings. The flag contains 35 stars.

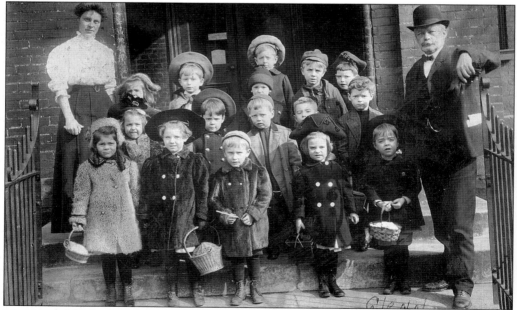

Members of the kindergarten class of Webster School pose with their teacher and Mr. Bratton, the truant officer, in 1908. Note the lunch baskets and high-button shoes. Originally an eight-classroom elementary school, Webster was constructed in 1870. Years later, it housed high school classes. In 1938, it closed because of a declining enrollment. Webster served an art center for the Federal Works Administration and then, in 1939, as temporary quarters for the Altoona branch of Penn State.

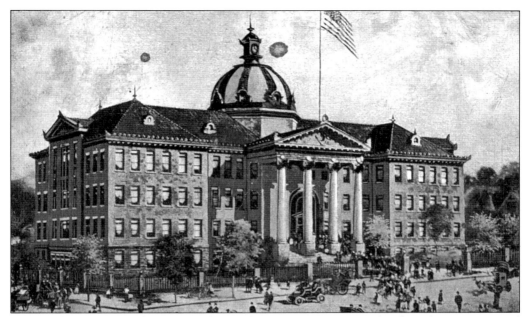

The first high school in the area was designed in Romanesque Revival style and was constructed in 1894. Altoona's first high school graduates received their diplomas at Webster School. In 1905, a neoclassical building was erected to house the high school. Constructed of Hummelstown brownstone, it contained 25 classrooms, a science department and laboratories, a spacious gym, a library, offices, and an auditorium seating 1,500 patrons. It also made provision for a manual training department.

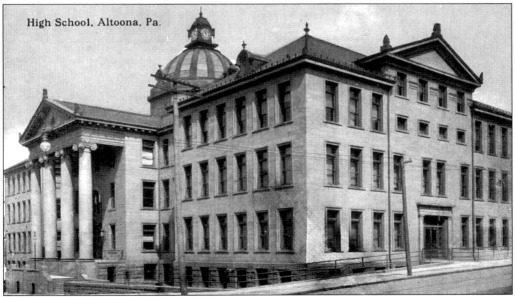

The rising school population mandated that an annex be added to the high school in 1926. The annex was constructed on Fifth and Sixth Avenue lots that were purchased from the Jaggard Estate. The building, which had an automatic signal system and a telephone exchange, made Altoona High the best-equipped school in the country at the time.

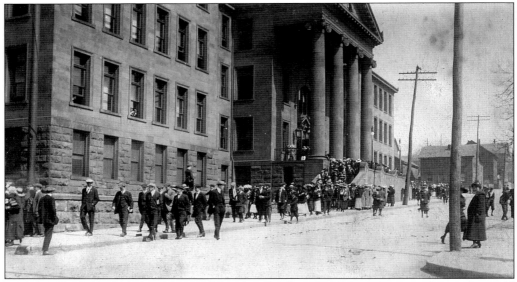

In 1931, the high school participated in an official study of the relations of secondary and higher education, conducted by the Carnegie Foundation. Two years later, it became one of 30 schools in the nation to be included in an eight-year Progressive Education Association study of the relations of the school and college. Interestingly, Altoona ranked highest in library science. The overall results of these studies led to some significant changes.

Practicing in perfect formation, the Altoona High School band performs at Mansion Park Athletic Field in the 1960s, with the color guard, head majorette, and featured twirler out front. The band regularly took part in city parades. Baker Mansion is in the background behind the trees.

For the 1930–1931 academic year, the faculty of Theodore Roosevelt High School consisted of Principal Burd and 45 teachers. The school was named in honor of the nation's 26th president, who visited Altoona while campaigning for office. Constructed in 1921, the school also housed the public library.

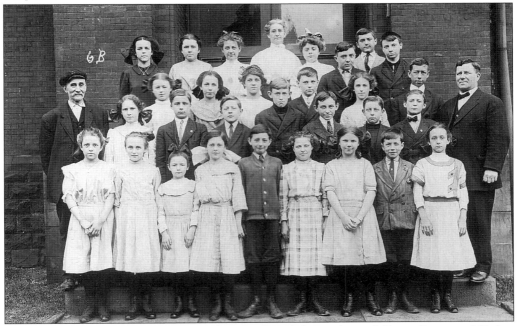

Altoona students pose in April 1912. They are, from left to right, as follows: (front row) Esther Seasoltz, Mabel Royer, Alberta Dell, Mary Lingfelt, George Dougherty, William Kekolus, Lesslie Norris, Joseph Segrist, Edgar Little, and Wade McDonnell; (middle row) Alton Briggs, Caroline Hoffman, George Bockel, Gertrude Bundschuh, Hazel Wendt, Evelyn Stephens, Myrtle Stackhouse, Fred Latherow, Robert McFalls, and Charles Fawler; (back row) Myrtle Stoner, Carl Satterfield, Amelia Booser, Margaret Finley, Emil Neher, Clara Bannan, Wilhelmina Hess, Lois Russell, and Edna Osman.

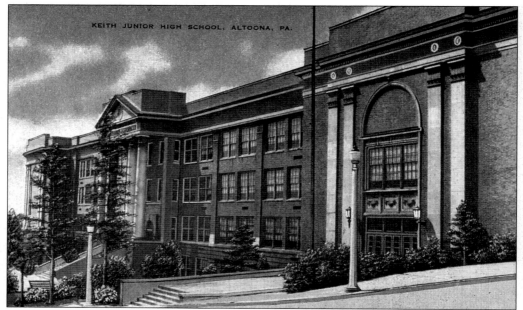

Keith Junior High School was opened in 1930 on a site between Nineteenth and Twentieth Avenues. Named in honor of former superintendent D.S. Keith, the building was designed to accommodate 500 pupils.

Logan Junior High School is located in the Greenwood section of Altoona. It is named for John Logan, a Cayuga chief. Logan was an original resident of the Altoona area. Educated by Moravian missionaries, he had a cheerful perspective and numerous friends among the white people. During the Revolutionary War, he was employed as a spy for the colonists. He and his wife, a Shawnee, had one son, whom they called Little Logan.

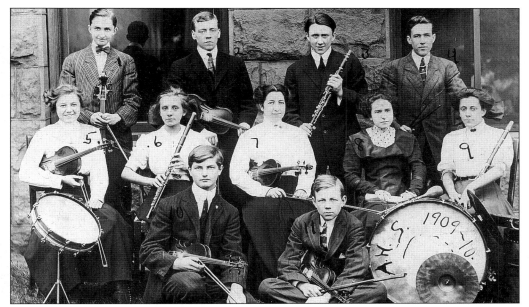

High school bands entertained at the school as well as at civic and religious functions. Pictured are members of the 1909–1910 Altoona High School Band, from left to right, as follows: (front row) Ralph Miller and Charles Crumbaker; (middle row) Hilde Geesly, Dessa Heeter, Annie Wrigley, Alma Roudabush, and Grace Heeter; (back row) Paul Epright, Donald Yarnell, Harry Carins, and Robert Gable.

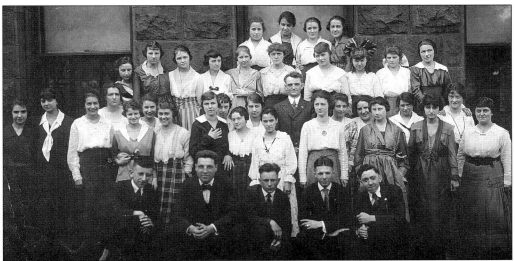

This is Altoona High School's 1918 commercial studies class. Pictured from left to right are the following: (front row) Martha Abelson, Louella Cox, Regina Kelly, and Maud Dodson; (middle row) Betty Proudfoot, Edna Englend, Vesta McGuire, Elizabeth Dixon, Alice Bender, Beatrice Raffenpage, Amelia Booser, and Bessie Bill; (back row) Dolly Fields, Charlotte Schimminge, Jeanette McKnight, Mary Hinterbiter, Edna Schules, Pauline Davis, P. Fleck, Josephine Auranlt, May Peoples, Wilimena Kutz, Alberta Dell, Ruthellen Sentella, ? English, Beatrice Cohe, Marie Reney, Marie Auber, Gertrude Burke, Anna M. King, Leona Fleck, Firn Negley, ? Mortimer, Sidney Koch, Matt Sanders, Charles Hoover, Ornyle Wise, and George Sutton.

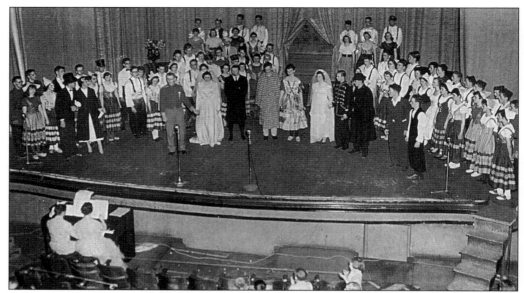

The senior class of Altoona Catholic High School performed the operetta *The Red Mill* in the Mishler Theatre on April 28, 1955. The school was established at 1100 Sixth Avenue in 1922 by Bishop John McCort, the second bishop of the Diocese of Altoona. In 1922, the cornerstone was laid and, by February 5, 1923, the new building was complete. Classes began with Rev. Patrick T. Harkins as the first principal. The original building is now the Altoona Beauty School of Hair Designing and Cosmetology.

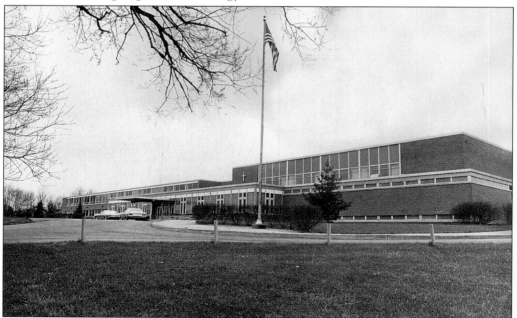

Bishop Guilfoyle High School was constructed on Pleasant Valley Boulevard in 1961. It was named for the third bishop of the Diocese of Altoona, Richard Thomas Guilfoyle. An additional wing was added in 1984, but it was not until 1987 that all the local Catholic high school students were able to be accommodated in the new building.

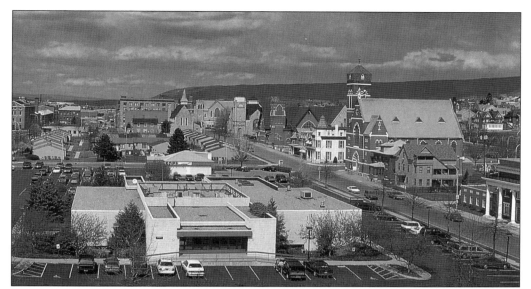

Eighth Avenue might well have been called the Isle of Worship. Within one block there were five churches of various denominations: St. James Lutheran, an imposing edifice built in 1889; Faith United Methodist; St. Luke's Episcopal, built in 1915; New Covenant Fellowship; and Mount Carmel Catholic, established in 1906 to serve Italian immigrants and staffed by Franciscans.

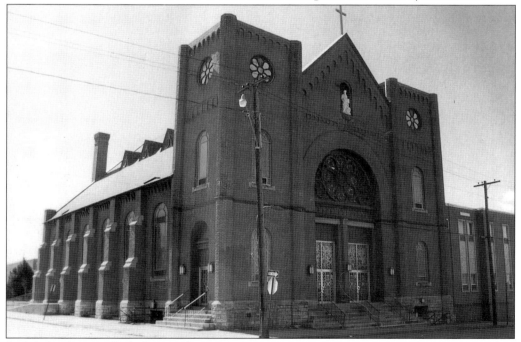

St. Mark's Roman Catholic Parish came into existence in answer to a need. In 1890, Bishop Phelan of Pittsburgh created the parish on the east side of the city so that parishioners no longer had to cross the bridge to go to church. Initially, an old academy building was fitted as a temporary church for the 2,300 parishioners. Then, in 1891, a new church was erected on Fourth Street and Sixth Avenue.

81

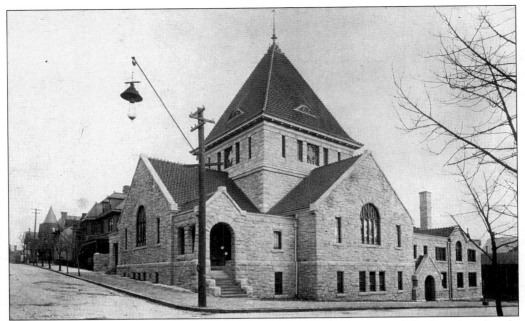

The first recorded sale of land in Altoona provided the site for the original Presbyterian church, on the corner of Twelfth Avenue and Thirteenth Street. After that church burned in 1855, the second Presbyterian church was built on Eleventh Avenue. It served the congregation for four decades. The present Congregational church, of Romanesque Revival style, opened on Fourteenth Avenue and Twelfth Street in 1896.

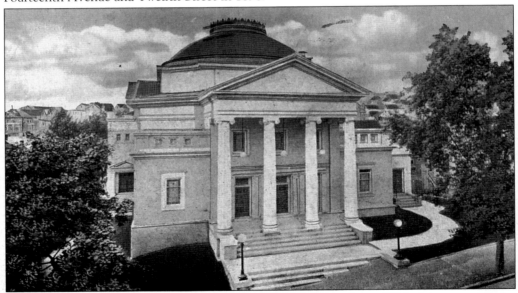

The Baptist church on Seventeenth Street was dedicated in 1916. Itinerant Baptist missionaries had been preaching in the area since 1815. In 1842, a 21-member log church was established in Pleasant Valley and, in 1853, the congregation moved into the Union Street Schoolhouse on Eleventh Avenue and Sixteenth Street. Many other congregations had their beginnings here.

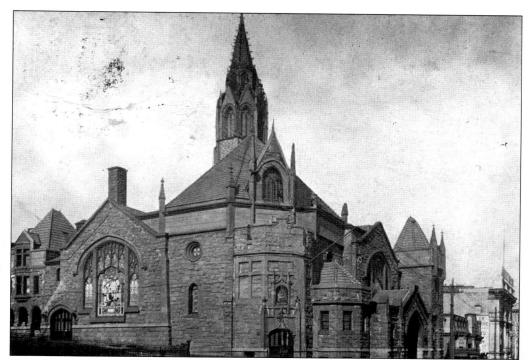

The United Methodist Church at Twelfth Avenue and Thirteenth Street stood on property donated by John A. Wright, whose father was a railroad agent. Constructed of Hummelstown brownstone in 1905, the building featured a trim of smooth stone, a steeple that was 115 feet high, and room to accommodate 1,000 people. In 1936, the church was struck by lightning and the steeple was removed.

Lutheran services were originally held in private homes and other locations within the city. After the Altoona parish was formed in 1815, services were held in a log church. In 1854, a two-story brick edifice was constructed on Eleventh Avenue. When the congregation outgrew that location in 1897, the present stone church, the First Lutheran Church, was built on the corner of Twelfth Avenue and Fourteenth Street.

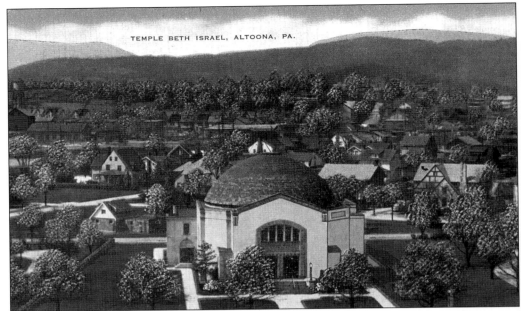

TEMPLE BETH ISRAEL, ALTOONA, PA.

Temple Beth Israel was constructed in 1924 on Union Street in the Columbia Park section of Altoona. Members of the Jewish faith had been active in town since 1877. In 1896, they chose a site on the corner of Thirteenth Avenue and Fifteenth Street and built a house of worship there. They used that original temple until Beth Israel opened.

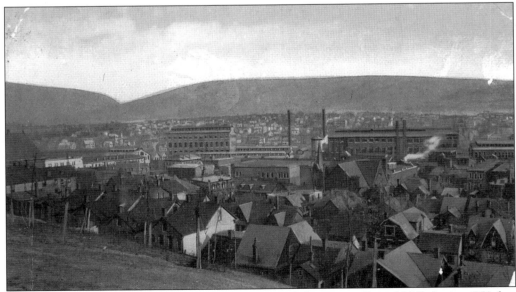

The highest point and the center of the city is a park known as Gospel Hill. It rises 250 feet above the streets and affords an unobstructed view of the valley. Located at the top of Fourteenth Street across Thirteenth Avenue from Blessed Sacrament Cathedral, the hill was purchased by the city from John Wright in 1871. It acquired its name because evangelists and preachers once gathered their flocks there and delivered "sermons on the mount."

Five
ALTOONA TAKES ITS PLACE IN HISTORY

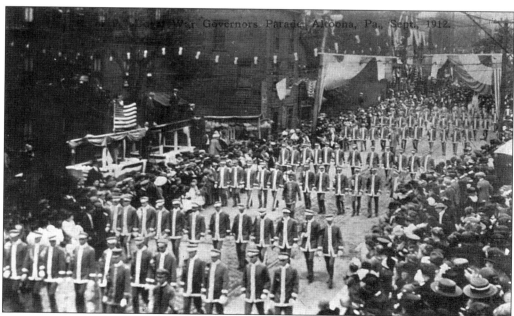

A regiment of Pennsylvanians marches in a parade commemorating the semicentennial of the Conference of Loyal War Governors. In September 1862, the governors met for just over an hour in the Logan House. They unanimously passed resolutions proclaiming a spirit of cooperation among the northern states, word of which was dispatched to Pres. Abraham Lincoln. The governors stayed in Altoona for two days and, thus, were able to discuss other issues of the time. Pennsylvania Gov. Andrew Curtin hosted the visit.

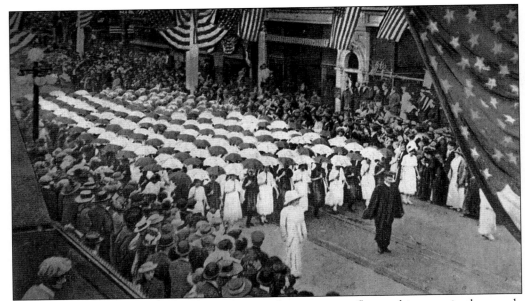

A living flag moves along Eleventh Street, one of many unique floats taking part in the parade on the 50th anniversary of the Conference of Loyal War Governors. The flag was formed using more than 150 red, white, and blue umbrellas. The September 1912 parade celebrated the historic conference, which raised the morale of the Northern states, united them, and restored their faith in the federal government and the president.

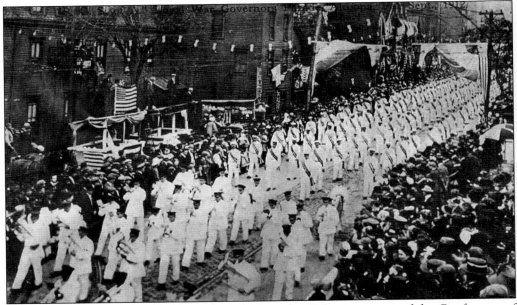

All organizations took part in the parade marking the 50th anniversary of the Conference of Loyal War Governors. Realizing that the union was in grave danger, Gov. Andrew Curtin of Pennsylvania called the 1862 conference to discuss active support of the government and the president. He issued invitations that read, "We invite a meeting of the governors of the loyal states to be held in Altoona, Pennsylvania, on the 24th instant." Thirteen governors came.

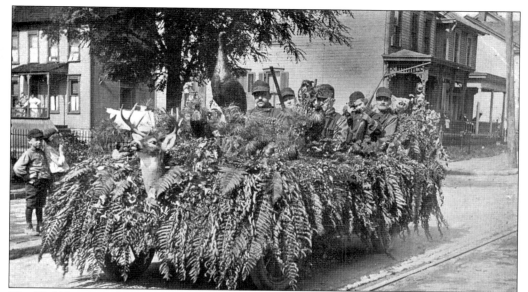

The Wolf Brothers float takes part in the September 1912 parade marking the 50th anniversary of the famous conference held at the Logan House. The anniversary celebration went on for three days in commemoration of the meeting, which marked a turning point in the Civil War. The 13 governors in attendance pledged their loyalty to the president and their confidence in the cause of the North.

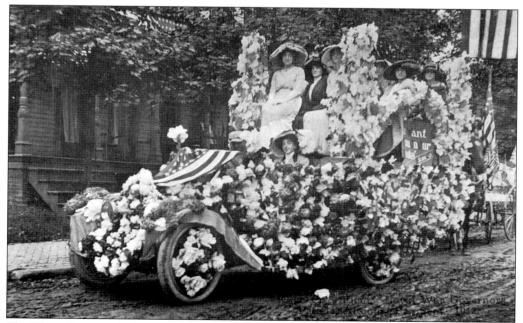

The Kline Company's float was one of the many in the Loyal War Governors semicentennial parade. Pres. William Howard Taft attended the three-day celebration in September 1912, as did many high-ranking officials from around the country.

The drive east along Lookout Avenue in Wopsononock offers a magnificent view of Altoona, nestled below in the valley. At night from this high vantage point, the lights transform the city into a twinkling jewel. In 1890, the Wopsononock Real Estate company sold lots on the mountain. The first purchaser was Harry Step, founder of the Altoona Mirror, who later built and maintained a summer cottage on Wopsononock mountain.

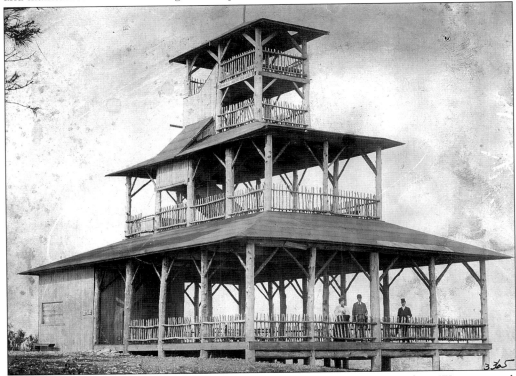

Wopsonosock Mountain rises 2,600 feet above sea level, and the 40-foot Wopsononock pavilion stands 1,400 feet above the city. From here, amidst a breathtaking panorama, Altoona appears to be miniature city.

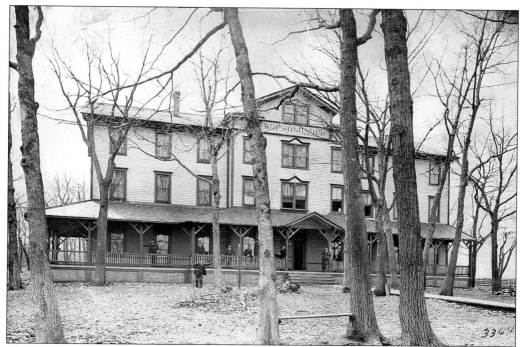

The spacious Wopsononock Hotel was built in 1891. Situated high on a bluff overlooking Altoona, the three-story hotel loomed as an imposing spectacle over the city below. Attractive to fresh air seekers, the hotel featured 60 well-furnished, comfortable rooms. However, its career was short-lived: 12 years after it opened, the building was destroyed by a forest fire and was never rebuilt.

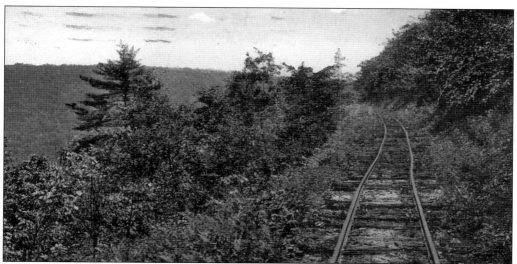

The railroad to Wopsononock Mountain started operating on June 11, 1891. The train consisted of a locomotive, a tender, and three open-air passenger cars with seats for 24 passengers. The 70-minute trip offered both a scenic vista and a challenging adventure. The route went over Sandy Gap, skirting the deep, narrow gorges. This rail line remained open for three decades.

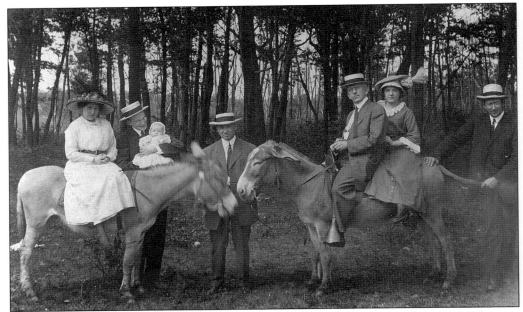

Members of the Miller-Schenk family enjoy an excursion to Wopsonosock c. 1900. They are identified as follows: Fred Miller with his wife and baby daughter, Paul Schenk (center), and Dr. Miller with Ruth Schenk and Russell Miller. Many Altoonans still visit Wopsonosock for the scenic view overlooking the city of Altoona. Mules, with their gentle, calm, and amiable dispositions, have long been used as work animals in the Alleghenies.

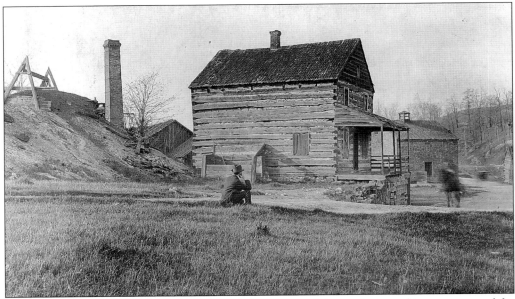

A tall furnace stack rises in the background above one of the crude log cabins constructed for the Baker employees. It is thought that Elias Baker resided here while his palatial mansion was under construction. The building in the background was the company store, tended by Thomas Johnson. At the far right is the office that later served as the Altoona Women's Club.

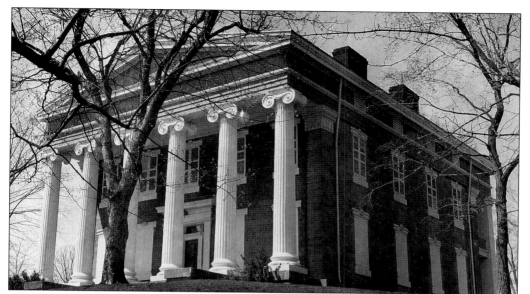

Elias Baker (1798–1864) built the Baker Mansion in 1848. He had been living in a company house and needed something more befitting his status as an ironmaster. Baker married Hetty Woods, and the couple had three children—David, Sylvester, and Anne. Designed in the style of a Greek temple, the mansion measured 50 feet by 75 feet. The thick exterior walls were made of limestone braced with strips of lead. Much of the exterior decorative window trim was cast in the Allegheny Furnace.

For 16 years, Elias Baker managed the mansion and estate. When he died in 1864, his son Sylvester took over. Twenty years later, the real estate company Baker Estates was formed to develop residential lots from Baker's 5,000 acres. Anne Baker was the last resident to live in the mansion. In 1922, the Baker Mansion became the home of the Blair County Historical Society.

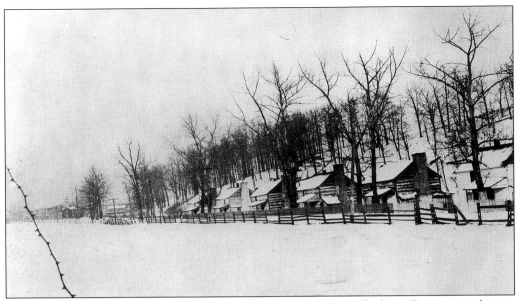

Ironmaster Elias Baker built cabins along Union Avenue for his Allegheny Furnace employees. The cabins measured 20 by 25 feet and were a story and a half high. These cabins sold for $50 each in 1905, and the area came to be known as Log Cabin Court. In 1920, the dwellings were razed to make way for an expanded Union Avenue.

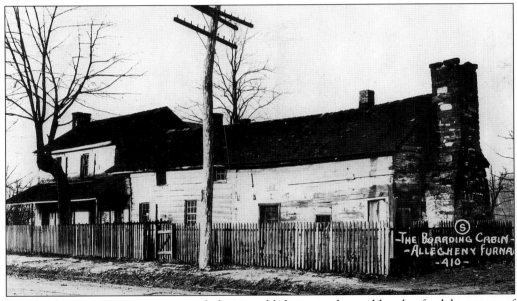

Boardinghouse ironmasters managed their establishments almost like the feudal manors of Europe. Employees lived in the master's cabins and were dependent on him for the necessities of life. All purchases, including food, clothing, and medicine, were made in the company store. Many of Elias Baker's employees lived in cabins. However, when the number of employees exceeded the number of dwellings, there was always the boarding cabin.

Long since abandoned, this is the last of the Allegheny Furnace cabins. After standing for more than eight decades, it was razed on May 1, 1939. As the area progressed, the cabins became relics of the past and were taken down, one by one.

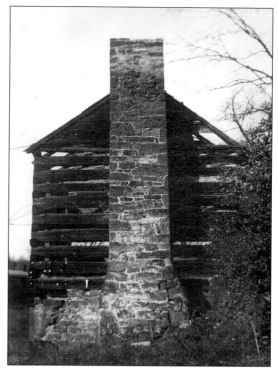

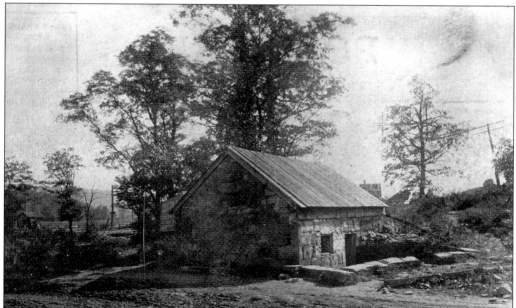

Springhouses of an early vintage were built to protect the water supply for the estate, the mansion, and the Allegheny Furnace. Elias Baker had one large springhouse across Logan Boulevard and another at Thirty-fifth Street and Third Avenue. Under the springhouses ran mountain springs that stayed cool even in hot weather. Also, food was often stored in the springhouse and then brought in for meals.

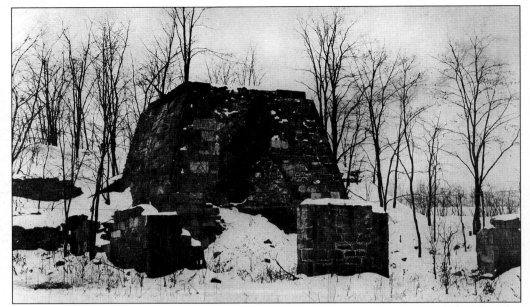

Allison and Henderson of Huntington built the Allegheny Furnace in 1811 and abandoned it seven years later. In 1836, Elias Baker bought the furnace, and it remained in operation for the next seven decades. Baker owned the section of the mountain that provided the iron ore. He established himself and his family, complete with a mansion, near his mines and the furnace. Much of the iron by the Allegheny Furnace was sent to Johnstown and Pittsburgh.

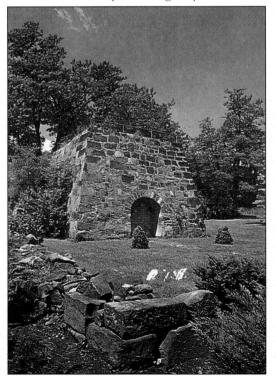

The Allegheny Furnace, the second oldest furnace in Blair County, was a huge operation. The iron industry required some necessary ingredients: iron ore from the land, limestone, water, and huge amounts of timber to produce charcoal, which fueled the furnaces until c. 1850, when coke became more plentiful.

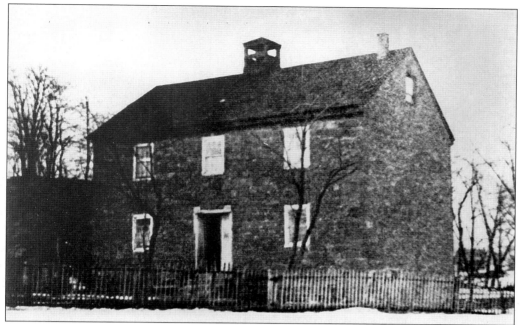

The Altoona Women's Club is the oldest historical site in town. Built in 1818, it served many purposes and at one time belonged to Elias Baker, who owned the Allegheny Furnace next door. The club was a storehouse, an office, and home for the superintendent of the Allegheny Furnace. In 1882, it was a tearoom. Later, it became the Altoona Women's Club. In 1954, the clubhouse was enlarged to accommodate the growing membership.

Mansion Park is an 18-acre expanse of land adjoining Baker Mansion. In 1923, it was bought as an athletic field for the high school. The field was developed in 1928 by the architectural firm Nicolette and Griswald of Pittsburgh.

Charter members of the Blair County Historical Society in 1957 gather at the Baker Mansion. The are, from left to right, as follows: (front row) Bertram Leopold, Otto J. Pippart, and Judd D. Minnich; (back row) the Honorable Atlee Brumbaugh, the Honorable J. Banks Kurtz, Maj. A.O. King, and Roy Thompson.

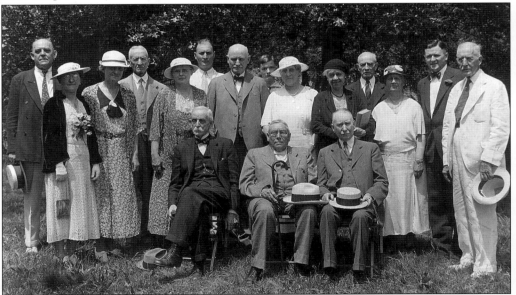

Blair County Historical Society members meet in 1934. They are, from left to right, as follows: (front row) William Woodstock, Plymouth Snyder, and Harry Jacobs; (back row) Dr. Guy S. Robb, Bertha McLaughlin, Anna Berg, Tarring Davis, Mary Jeffries Ayres, Floyd G. Hoenstein, Matthew Morrow, Donald Yoder, Mary Morrow, Margaret Nicholson, Walter Irvine, Nellie Berg, William Canan, and Thomas Trout.

In pioneer dress, members of the Bridge Card Party Club of the historical society and the women's club pose on the steps of Baker Mansion. They are, from left to right, as follows: (front row) Mrs. Fred Massat, Annamae Jefferson, and Winifred McDowell; (back row) J.J. Hauser, Marjorie Marcuff, Peg Hagburg, and Virginia Krick. Held in 1946, the occasion was the first women's club card party.

Singers from Baker Mansion perform Christmas carols at the Railroaders Memorial Museum in 1970. The singers are Kelly Shaffer, Sylvia Emerson, Sue Sweetland, and Angela Wendle. Note the railroad posters in the background.

Members of the Altoona Artists Guild display their creations on the grounds of the Baker Mansion in August 1928. Seated in the chair is J.J. Hoover, curator of the mansion. Standing are Esther Bell, Mrs. Thompson, Haven Williams, and Samuel M. Ake.

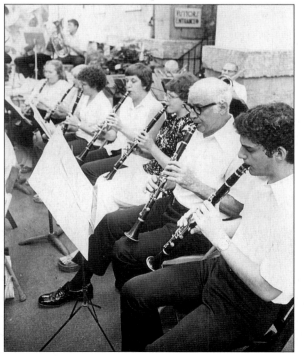

Summer evenings and Sunday afternoons, concerts are often held at the Baker Mansion. This July 27, 1979 performance features clarinet, tuba, and trombone. Bands play on the front lawn, and the music resounds throughout Mansion Park and down to the city below.

Margaret Leet Beckman enjoys a modern-day pleasure. She married Elias Baker's great-grandson Albert Beckman and, with him, resided in Sweden for a time. She then returned to Altoona and built the white house adjacent to the Baker Mansion. After he died in 1914, she married a Mr. Wade. Albert Beckman was the only child of Louise Baker Beckman, who in turn was the only child of David Woods Baker, son of Elias Baker.

Wheels from the old portage railroad are dedicated on the rear lawn of the Baker Mansion. Attending the ceremony are J.L. Hartman, M.A. Miller, Barbara Frey, Reverend Cullighan, H.O. Woolson, M.W. Hazel, Hon. James Brombaugh, J.J. Hauser, William Leibcott, Floyd Honestine, Robert Menchen, John Dillen, Louis Swarton, and William Canon.

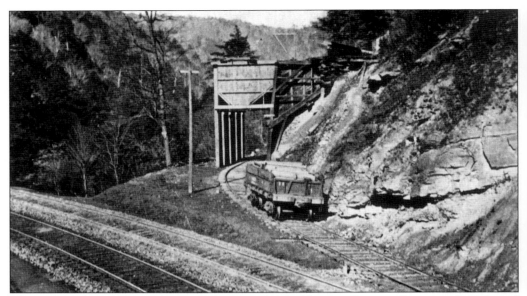

The coal tipple at Baker's Mines stands out at the double spur. Burgoon Run is to the left, and Kittanning Run to the right. The Kittanning Railroad station served Horseshoe Curve for a half century and was demolished in 1904. The area was widened and the curve became four tracked, making the train service between cities more efficient. Horseshoe Curve has been part of the railroad line for a century and a half.

This is Elias Baker's Ore Bank, near Altoona, as it appeared in 1955. J.P. Leslie, in the *Iron Manufacture's Guide* for 1859, stated: "The hill extends southwest and feeds Allegheny Furnace. The ore bank is nearly two hundred yards long and a hundred feet deep. It is cut from the south side of an upper limestone ridge which faces Bald Eagle three miles northeast of the furnace and nearly opposite Blair Furnace which sometimes mixes its ore with its own fossil ore."

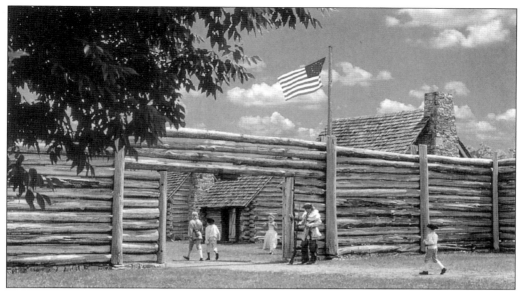

Fort Roberteau was a lead mine fort. In 1778, authorities discovered lead deposits in Sinking Valley. Gen. David Roberteau—working with a militia, miners, and smelters—established lead mining in the region. Lead was valuable in the production of bullets for use by the American forces against the British. Roberteau erected a fort to protect the miners, his troops, and the mining operation. Fort Roberteau also proved a safe haven for area settlers. Mining was abandoned in 1780. The stockade and cabins have been refurbished.

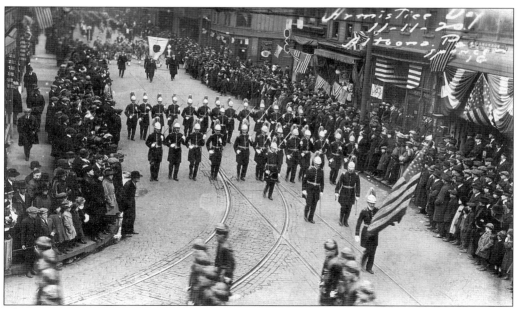

The Armistice Day parade marches along Eleventh Avenue on November 11, 1920. It had been two years since the armistice had been declared at the end of World War I. In patriotic fashion, the returned veterans and their families celebrate with the parade and other festivities. Note the bunting on the buildings.

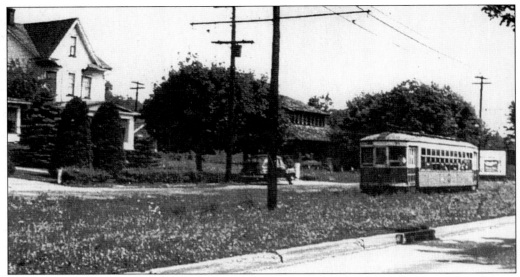

The first trolley company in Altoona was the Citizen's Railway. Its initial run was along Logan Boulevard. In 1891, the Altoona and Logan Valley Electric Railway companies merged, and the first electric trolley was established. Trolley lines were gradually extended into neighboring suburbs. Trolleys, or streetcars, became the principal means of transportation throughout the city. In 1923, the Logan Valley Bus Company began taking over the trolley routes.

As automobile travel increased, the streetcar became obsolete. After being part of the Altoona scene for many years, this trolley made its last run on July 18, 1954. It carried a group of trolley car buffs along Logan Boulevard to Lakemont Park. In December 1954, a dedication ceremony took place at the Baker Mansion. Attending were former streetcar employees, including T. Canan, on the left in the front row, and J.J. Hauser, fourth from the left.

Six

THE WAY WE WERE

The Lakemont area was singled out in the early 1800s as an ideal place for a park. Volunteers were organized to clear a portion of the thickly wooded area. It was obvious that in order for a park to succeed, transportation was a necessity. In 1893, the Logan Valley Electric Railway Company held a picnic meeting in the area, and that was the first step toward the development of Lakemont as a park. This particular site featured a spring that was called Jacob's Well.

The president of the Logan Valley Electric Railroad, John Lloyd, obtained a 113-acre parcel of land and, in 1894, he deeded it to Lakemont Park for the purpose of creating a man-made lake. A pan, or double-handled instrument, was hitched to a team of horses and the earth was scooped out. This created the picturesque lake that is Lakemont. It has provided pleasure and recreation for generations.

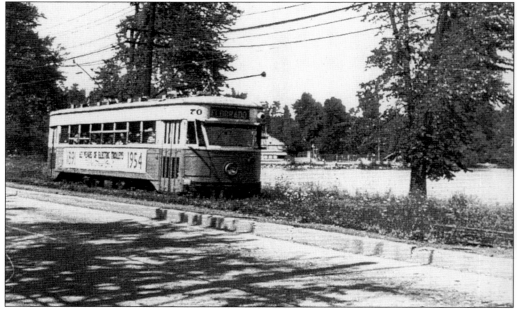

In 1891, the electric trolley became a reality. A trolley line was built along Logan Boulevard from Altoona past Lakemont to Hollidaysburg. The construction of an amusement park was in the plan. To handle the crowds that came to the park, loops that formed a triangle were installed behind the station. The first loop went around the greenhouses, easing traffic congestion. Note the casino in the background.

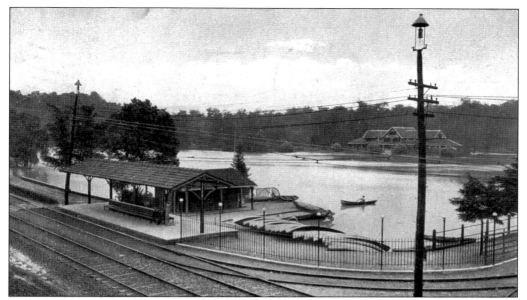

The station pavilion and boathouse greeted visitors to Lakemont. When the trolley arrived, visitors had the option of renting a boat or walking across the top of the dam to the park. One park patron chose to row across the lake. Note the tracks going in various directions, where the trolley made a loop around the greenhouses.

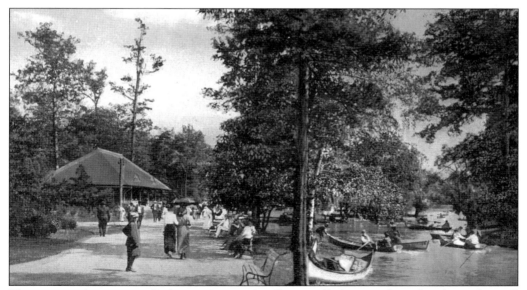

The promenade was one of Lakemont's several walkways, all pleasant places for a leisurely stroll with friends. Canoeing was a favorite sport, and the annual Canoe Regatta was the highlight of the summer season. In the 1920s, young men often entertained their dates by paddling around the lake in a decorated canoe with a windup Victrola. Members of the Canoe Club stored their boats in an old basket house near the streetcar station.

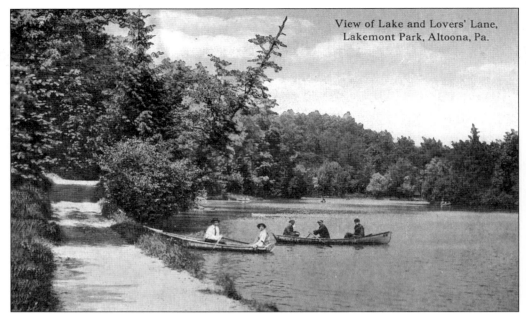

View of Lake and Lovers' Lane,
Lakemont Park, Altoona, Pa.

Lover's Lane follows the old rail bed from the days of ore mining at Lakemont. At one time, ironmaster Elias Baker owned all the land in this view. When Baker's storekeeper Thomas Johnston discovered ore on the land, Baker laid a railway to transport the ore to Allegheny Furnace. There were four mines in what is now Lakemont Park, all of which were closed and sealed when the furnace shut down.

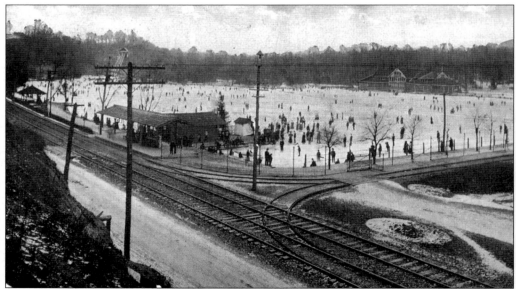

Ice-skating in Lakemont Park was a popular sport in the first half of the 20th century. As soon as the ice was eight inches thick, a bright red ball was placed on each trolley as an indication that the ice was now safe for skating. Usually from Thanksgiving until March there was little danger. Logan Valley Electric Company sent teams of horses to scrape snow off the ice. Young men organized the Lakemont Hockey Team, which played teams from Tyrone and Bellwood.

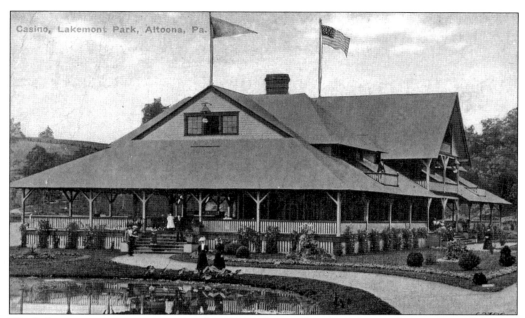

The Lakemont casino was completed in 1890. Originally called the pavilion, it housed dances, social affairs, meetings, and theatrical performances. In the winter, skaters came into the casino to thaw out in front of its huge fireplace. In those days, planks were laid as a walkway for skaters to preserve the maple floor. In the summer, passengers ascended steps from a boat onto the veranda. Live entertainment was provided. In 1916, Fred Waring made his first professional appearance as part of a four-piece band at Lakemont.

A spacious outdoor pavilion that could accommodate 1,000 people was constructed for the benefit of open-air dancing. Located near the casino, the pavilion consisted of a roof supported by pillars. The open-air aspect was a new innovation at the time. Live music or windup Victrolas supplied the entertainment. Altoona High School seniors who attended Afterglow, the free night at the park for graduates, fondly recall the dance pavilion.

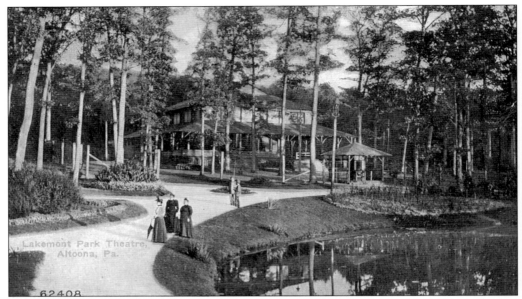

The Theatre in the Woods, also known as Lakemont Playhouse, opened in 1892 as the first summer playhouse in the country. General manager Lee Shannon made all performances free of charge for the first few years. Many vaudeville acts were dramatized at the historic theater. Stock companies performed here and brought many celebrities to the area. Among them were Maude Adams, the Barrymores, Betty Gable, and Peggy Martin. In June 1892, the state Democratic Convention was held at Lakemont.

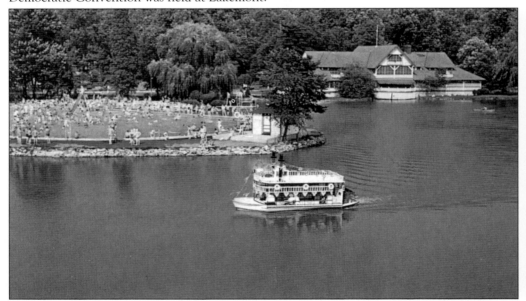

The Blue Island Pool was unique to Lakemont. Frank Hunter of the Altoona City Council conceived the idea of a pool within the lake. His reasoning was that the park was full of trees, and a pool must receive sunlight to warm the water and keep sunbathers happy. The fan-shaped pool, constructed in 1939, featured a diving board, bathhouse, and concession stand. In 1957, a replica of a Mississippi sternwheeler set sail in Lakemont.

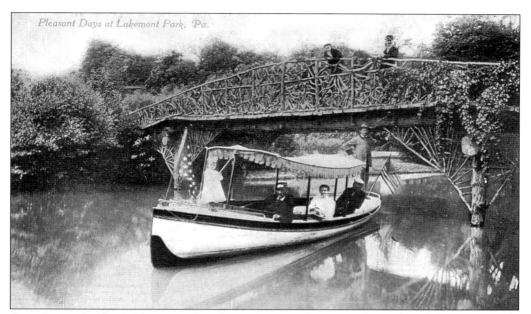

A rustic wooden footbridge spans the lake—a fine spot for a quiet, leisurely sail. In its very early days, Lakemont Park had Weaver's Souvenir Stand. This postcard was made exclusively for that shop. Note the little girl standing in the bow of the boat.

The Skyliner roller coaster climbs to a dizzying height of 120 feet. It is the only L-shaped roller coaster in America. Altoona's rich heritage as a railroad center is displayed in this historic little railroad that weaves its way around the park. Fishing was a favorite sport. Leftover popcorn was tossed into the water at night, and then the fish had a feast. Lakemont fish were heftier than their less fortunate counterparts.

Lakemont had amusements to intrigue people of all ages. The carousel had a good selection of animals, and its music sounded throughout the park. Live pony rides fascinated children, especially those whose only contact with a horse or pony was at Lakemont. A peaceful train ride wound through the woods, crossed three bridges, and rounded Ponyshoe Curve. For small children there was a playground with swings and seesaws near the picnic grounds.

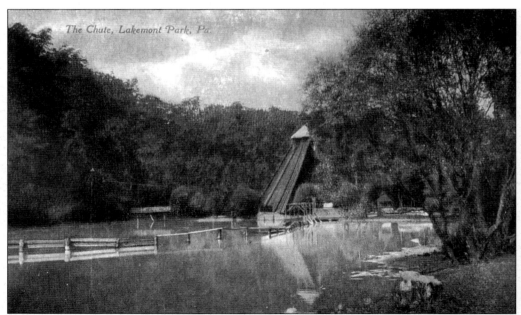

The more daring visitors chose Shoot the Chute, a ride in a large toboggan that plunges down a steep incline and skims across the water at high speed. The Twister was a roller coaster that seemed to turn on its side when rounding curves. The Bamboo Slide started at the top of a tower and then spiraled down rapidly. Water slides were always popular, too.

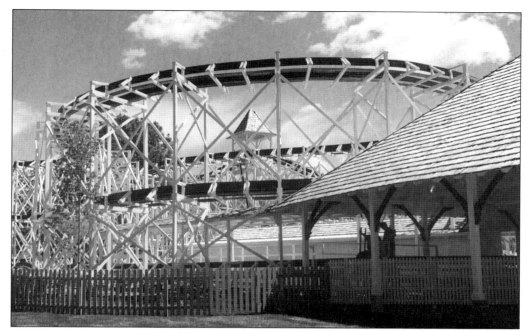

Leap the Dips is the world's oldest wooden roller coaster. It features seven cars, which travel at 10 miles per hour through an interlocking figure eight, punctuated by a series of nine-foot dips. It was constructed in 1902 by Joy Morris of Philadelphia for the enjoyment of thrill seekers at Lakemont. Rides of that time were tamer and milder than those of today.

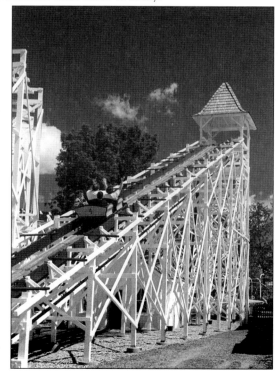

Leap the Dips was originally called the Gravity Railroad. It has been restored and operates today at its original site in the amusement park of Lakemont.

Members of the Anthony family display their gifts in December 1956. The father, Mayor Robert Anthony, stated that potatoes are a staple, especially those designated as Blue Label potatoes. The Pennsylvania Cooperative Potato Growers entertained the Anthony family following the official notification of his election as mayor of Altoona. The ceremonies took place in his office and, later, Anthony was declared mayor of Potato City.

The queen of the 1947 Central Pennsylvania Potato Blossom Festival (center) poses with her court in 1947. The contest was sponsored by the retail division of the Altoona Chamber of Commerce.

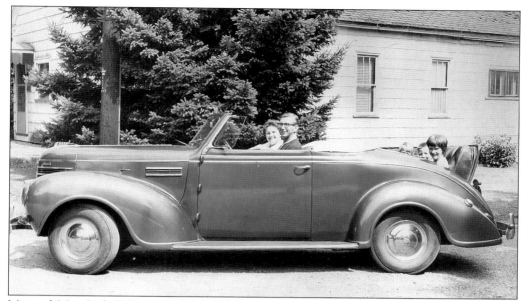

Mr. and Mrs. Jack E. Potts and their children, Marcia, Jeffrey, and Melanie, of Fifty-eighth Street set out on a Mystery Tour. Popular in Altoona for many years, Mystery Tours lead to surprising and interesting places. They were started by Ray Garvin. The youngsters seem to be enjoying the trip and the rumble seat of their 1939 Plymouth.

The Forest Zoo had the largest collection of wild animals in central Pennsylvania. The youngsters enjoyed Tall Paul, the giraffe, and the deer that came and ate from their hands. The zoo, located on a farm off the Coupon Road, was open for about two decades. Across the street was Fantasyland, full of nursery rhyme characters.

The Altoona Big Five basketball team of 1907–1908 consisted of L.F. Crosby, captain; R.F. Miller, manager; C. Turner; R.D. Williams; L.O. Bates; D. Robbins; P. Bennett; and Mr. Livingstone, assistant manager. The team won 27 games and lost only 5.

This 1904 photograph, taken on a diamond at Twenty-seventh Street and Broad Avenue, shows the post office employees' baseball team. Players are, from left to right, as follows: (front row) Jim Pierce, Herman Wentz, A.R. Goetz, and Ben Boycott; (back row) W.A. Loudon, C.V. Feidt, Gerald Costlow, J.C. Brallier, and Carl Smith.

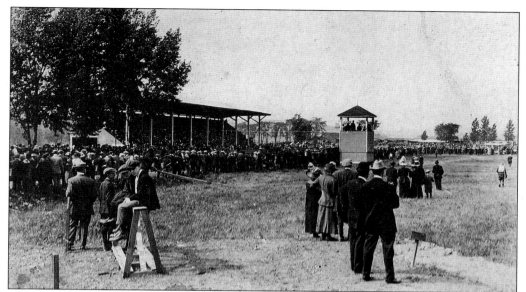

Fans pack the stadium as they await the start of the game. Baseball has always been America's favorite sport. The earliest baseball league was formed in Altoona in 1881. Sponsored by the railroad, the American Association listed Altoona as a member. The Clerk's League at the west end and the Shopman's League at the east end of Cricket's Field merged when competition with the Tri State Leagues was in order. Tri State was formed in 1904, and Altoona teams were charter members.

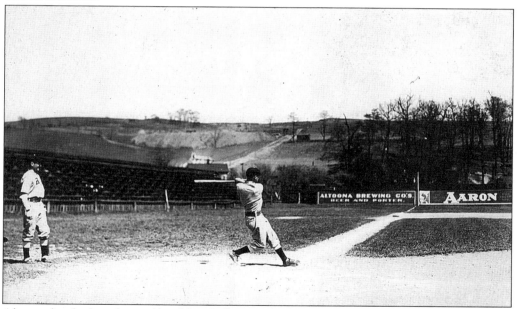

Altoona has had its share of local baseball stars who have achieved fame in the major leagues. Native son Perce Malone became a pitcher for the Chicago Nationals and participated in five World Series. Both he and Myles Thomas pitched for the New York Yankees. John Gochnour was a shortstop for the Cleveland Indians. He was later an umpire for the Altoona leagues. The sign in the background advertises the Altoona Brewing Company.

Blair County Ballpark, adjacent to Lakemont Park, is the home of the Altoona Curve Baseball Stadium. It is a new and welcome addition to Altoona. The first season opened on April 15, 1999. The Curve, affiliated with the Pittsburgh Pirates, bring minor league baseball to the area. The team's first victory came with a score of 6-4 against the Reading Phillies. One of the largest crowds, 7,443 fans, flocked into the stadium on July 8, 2000. The season attendance figure is in the 334,000 range.

The Altoona Curve Baseball Club offers many programs, among them the Field of Dreams Program. This gives Little League teams an opportunity to take the field with the starting lineup of the Curve for the National Anthem. Many former players advance to the major leagues. The Skyliner roller coaster of Lakemont, the parking lot, and McDonald's are in the background.

116

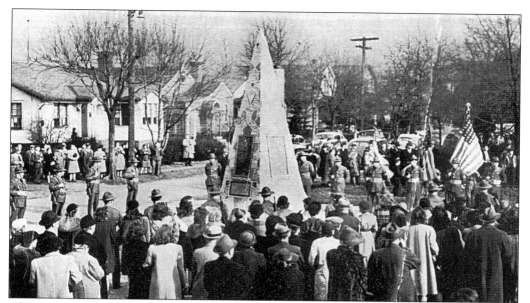

Altoonans gather for the dedication of the Veterans Monument in 1943. The memorial was erected at the intersection of East Southy, Bryant, and Tennyson Avenues by the Woodrow Wilson Civic Association.

The Altoona Park Racetrack was located at the Blair County Festival grounds. The grandstand accommodated 2,000 spectators, and admission was 25¢. The finest horses competed here, including the best of Col. John S. Vipond's fast trotters and pacers. In September 1890, Pres. William Henry Harrison was invited by the Exhibition Association to attend the races. Today, this is the Pleasant Valley Shopping Center.

The Driving Park Racetrack replaced horse racing early in the century. The new sporting attraction made its debut with the coming of racecars. The park was located at the old fairgrounds (now Pleasant Valley Shopping Center). Altoona became a mecca for professional racing. The dusty half-mile track opened prior to 1913 and closed during World War I.

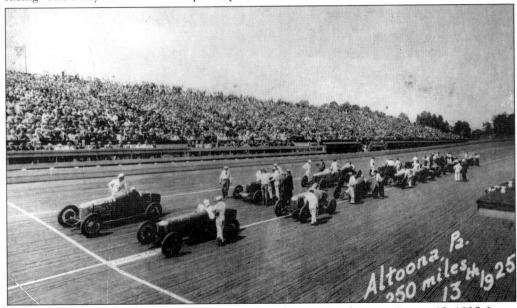

Racing cars line up for opening ceremonies at the Altoona Speedway on August 13, 1925. Large crowds thrilled to the car races and cheered the drivers on to victory. Some in the crowd secretly envisioned themselves behind the wheel of a Frontenac Ford, a Dodge, or a Stutz Bearcat, creating clouds of dust around the quarter-mile track. Leon Duray established the track record of 138 miles per hour in his front-wheel drive car.

118

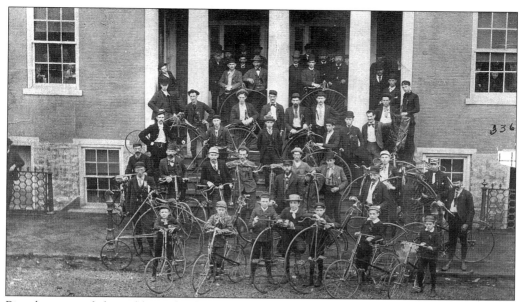

Bicycles were a fashionable mode of travel in the days before the automobile. People rode bikes for sport, for fun, and for commuting to work. These cyclists appear to be ready for a bike race c. 1900. The big front wheel was an asset to the rider because it propelled the bicycle forward with greater ease.

The Tour de Toona bicycle race began as a one-day contest in 1986. It grew rapidly and, by 2000, had become the largest such race in the United States. Called "America's premier bicycle race," it has brought Altoona worldwide recognition. Men and women participate on the same courses. The 320-mile race over rugged mountain terrain, craggy hills, and chasmlike valleys is now a six-day contest that draws thousands of participants and spectators each July.

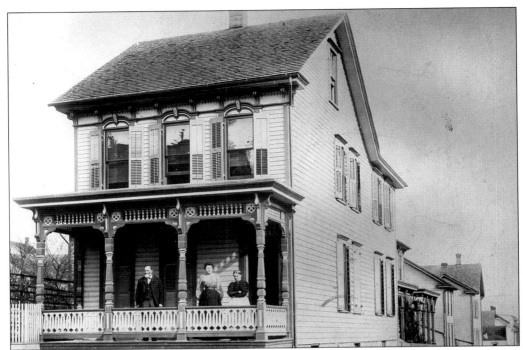

Caroline Smith and her sister are on the porch with Henry Smith at the Smith home on the corner of Eighteenth Street and Fifteenth Avenue. Many of the houses in Altoona were two-story dwellings with porches. People enjoyed their porches on summer evenings.

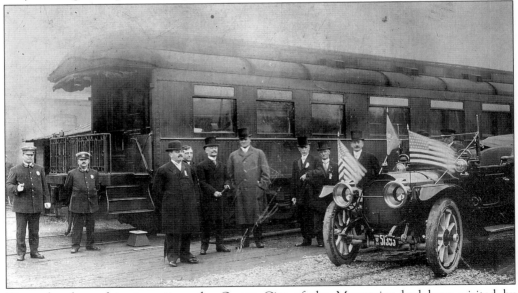

Since the days of its inception, the Queen City of the Mountains had been visited by dignitaries, celebrities, and presidents. In 1912, Pres. William Howard Taft rode the rails to Altoona. City officials and railroad personnel were on hand to greet the 27th president when he arrived. He held the position of chief executive from 1909 until 1913. A Yale graduate, he later became chief justice of the Supreme Court.

Seven

THE QUEEN CITY
OF THE ALLEGHENIES

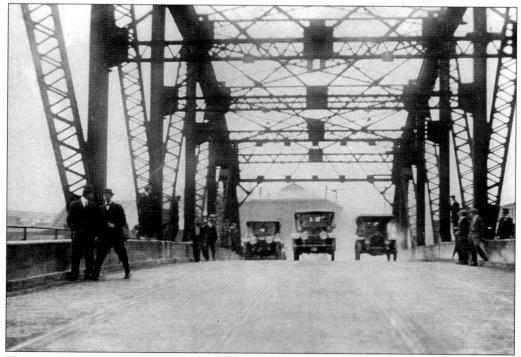

The new Seventh Street bridge was opened on September 20, 1913. The three first cars to venture across it were those of R.B. Vaughn, S.M. Griffith, and W.W. Crane. Altoona is divided by the railroad. There were bridges built at various locations over the railroad to prevent traffic congestion. Completion of the railroad brought great volumes of freight and passenger traffic through Altoona every day.

George Williams, a drapery clerk in London, founded the YMCA in 1844. Calling themselves the Young Men's Christian Association, he and his friends sought to cultivate the mental, physical, and social growth of young people. The organization came to Altoona in 1875. The YMCA gymnasium was built by Altoona citizens in 1920. It is designed in Italian Romanesque style of buff brick and was financed by a bond sale and local citizens.

The Benevolent Order of Elks, Altoona No. 102, met in this Renaissance Revival building, designed in 1905. Chartered in Altoona in 1888, this nationwide fraternal organization is founded on the principles of charity, justice, and brotherly love.

John Beaver drives this Ford early in the 1900s. Henry Ford of Detroit is credited with bringing rural folks to the city and city folks to the country by developing his low-cost automobile. Ford initiated the assembly line and mass-produced a car that everyone could afford. In 1908, the Model T appeared and became an immediate success. Note the crank in front of the vehicle.

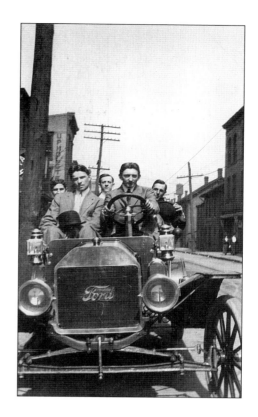

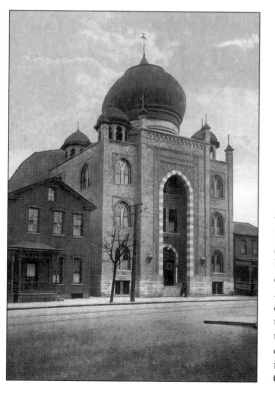

The original Masonic Temple was built in 1889 in the Victorian Gothic style. Located on Chestnut Avenue, it featured pressed red brick. It was among the edifices that dominated the commercial architecture of Altoona in the 1890s. The steeple consisted of a 12-foot-high brick portion, above which towered a 32-foot steeple. In later years, the tower and steeple were removed. Meetings of the original Altoona lodge were held first in the Presbyterian church and later in the Campbell Hotel.

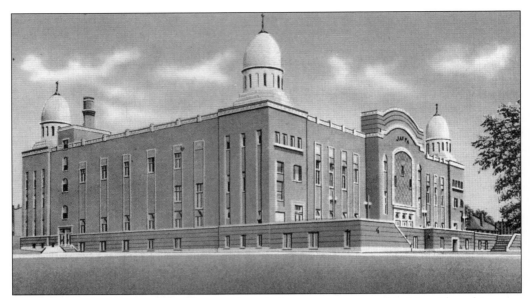

The Jaffa Mosque, home of the Shriners Association, was constructed in Moorish architecture on Beale Avenue in 1930. It was built by the Jaffa Temple Ancient Arabic Order of the Mystic Shrine. It is the largest facility of its kind in central Pennsylvania. The mosque lends itself to theatrical performances, sporting events, banquets, seminars, weddings, and organizational meetings. The interior is quite opulent and plays host to many spectacular events annually.

Miniature cars of the Jaffa Shrine take part in a parade. The little cars are used to raise funds for Shriners projects. Founded in 1872 in New York, the fraternal fellowship grew rapidly. Individual temples developed their own philanthropies. In 1919, all Shriners Hospitals for Crippled Children were united in a universal philanthropy. The Shrine Circus was founded in 1906.

The Jaffa String Band performs at various functions throughout the year. Dale Woomer, third from the right, is the director of this traveling band, founded in 1957. The band includes banjo, violin, guitar, clarinet, saxophone, piano, mandolin, and singers. The Shriners are best known for their colorful parades and distinctive red fezzes. Their official cause is the establishment of Shriners Hospitals for crippled children, of which there are currently 22 sponsored entirely by them.

Pride and patriotism are part of the Shriners tradition. The Jaffa Brass Band was founded in Altoona in 1959 to entertain and raise funds for Shriners Hospitals throughout the country. Here, Uncle Sam stands beside the band's trailer in the bicentennial celebrations. The band consists of drums, clarinets, horns, and cymbals. The men who make up the group come from all parts of the area and represent all walks of life. They are a dedicated fraternity.

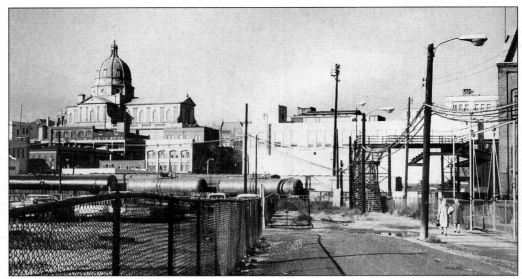

Altoona was always a railroad city. Seven decades after the city's establishment, an urban renewal project was deemed necessary as a way of protecting the tax base by removing blighted buildings. Property values increased, additional public facilities and citizens investments were better protected, and the breeding ground for disease and fire and crime was sanitized. The crane was involved in demolition. Housing for senior citizens rises on the left. The Twenty-fourth Street bridge provides an outlet for crossing traffic.

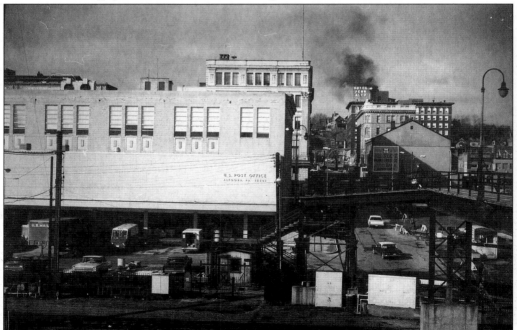

The Altoona post office was established on Eleventh Street at the site of what was once the famous Logan House. The Mishler Theatre is in the left background, and the Penn Alto Hotel is on the right. School projects, Tenth Avenue, Juniata, the hospital, and Eighth Street were targeted by urban development, and all benefited from the renovation project of the 1970s.

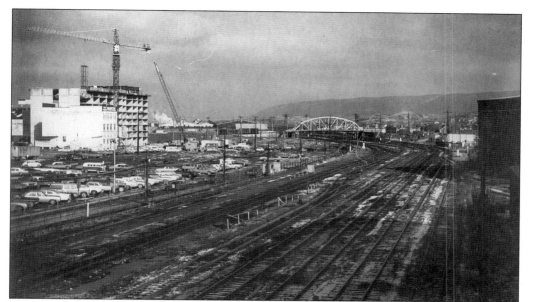

Conservation and protection of existing neighborhoods, rehabilitation and restoration of aged structures, revitalization of rundown neighborhoods, redevelopment and rebuilding of time-worn areas were all in progress at the same time. The city was revitalized as it reached its sesquicentennial. Today, Altoona remains a thriving industrial city of many enterprises.

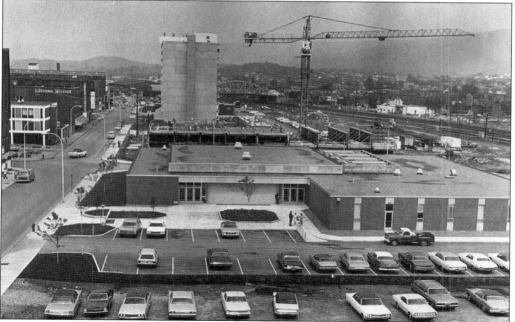

The Tenth Street renewal project featured a $1 million state office building, constructed by the General State Authority. The new 168-unit high-rise is part of the redevelopment landscape. A second high-rise of 11 stories with 208 units, for senior citizens, is also part of the project. The Seventh Street bridge, in the background, was renovated. The Penn Central railroad tracks are visible on the right.

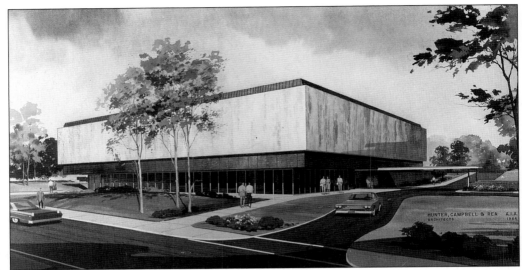

Altoona's original library of 1858 was the Mechanics Library. In 1920, the school district transformed it into a public library and moved it into Roosevelt Junior High School. In 1968, as part of a redevelopment program, a new library facility was constructed on Fifth Avenue and Seventeenth Street. The three-story, air-conditioned, automated library opened on June 15, 1969. It contains spacious circulation and reference centers, a children's room, audiovisual facilities, meeting rooms, and a theater.

Blair County Convention Center is located on a scenic bluff overlooking Altoona. The huge facility combines state-of-the-art technology with numerous functional and flexible options. It features a 24,000-square-foot exhibit hall and a 15,000-square-foot ballroom. The banquet facilities of this massive complex accommodate practically any size or type of event. Designed by L. Robert Kimball & Associates, the center is sponsored by the Allegheny Mountains Convention and Visitor's Bureau. Its specialty is hospitality a longtime legacy of Altoona.